EDGAR DEGAS

GEORGE T. M. SHACKELFORD

A TINY FOLIO™
ABBEVILLE PRESS PUBLISHERS
NEW YORK LONDON PARIS

In memory of my mother, Sue Madison Shackelford

Front cover: Detail of *Ballet (The Star)*, 1876–77. See page 172.

Back cover: *Family Portrait (The Bellelli Family)*, 1858–67. See page 49.

Spine: Detail of *Self-Portrait in a Soft Hat*, 1857. Oil on paper mounted on canvas, 10¼ x 7½ in. (26 x 19 cm). Sterling and Francine Clark Art Institute, Williamstown, Massachusetts.

Page 1: *Self Portrait*, c. 1864. Pencil on tracing paper, 14⅜ x 9⅝ in. (36.5 x 24.5 cm). Cabinet des Dessins, Musée du Louvre (Orsay), Paris.

Page 2: Detail of *Bathers*, c. 1896–1900. See page 269.

Page 6: *Self-Portrait: Degas Lifting His Hat*, c. 1863. Oil on canvas, 36⅜ x 26⅛ in. (92.5 x 66.5 cm). Calouste Gulbenkian Museum, Lisbon.

Page 22: Detail of *Scene of War in the Middle Ages*, 1863–65. See page 41.

Page 42: Detail of *M. and Mme. Edmondo Morbilli*, c. 1865. See page 53.

Page 80: Detail of *Woman on the Terrace of a Café in the Evening*, 1877. See page 101.

Page 122: Detail of *Racehorses before the Stands*, 1866–68. See page 129.

Page 150: Detail of *Waiting*, c. 1882. See page 193.

Page 204: Detail of *Woman Bathing in a Shallow Tub*, 1886. See page 223.

Page 234: Detail of *Woman at Her Toilette*, 1900–1905. See page 273.

For copyright and Cataloging-in-Publication Data, see page 287.

CONTENTS

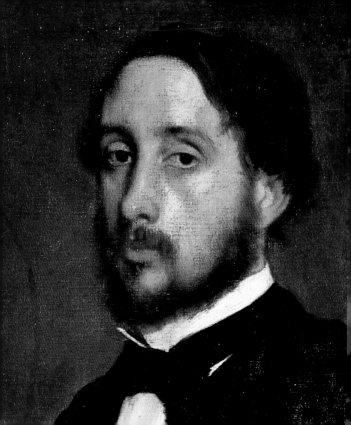

Introduction: Portrait of an Unknown Man

"I would like to be illustrious and unknown," Edgar Degas (1834–1917) said. Illustrious he certainly is today. Degas is instantly recognized as one of the most important of the Impressionists—though he despised that name, preferring to be called "independent." Widely considered one of the greatest draftsmen in the history of art, Degas is also admired for his subtle modulations of color, in oil or in pastel—innovations that rival the high-keyed hues found in the paintings of his contemporaries Claude Monet or Auguste Renoir. He is illustrious, above all, as the painter of the ballet, the creator of images dear to lovers of dance the world over. How ironic, then, is the journal entry of the young Degas, who confided that he felt "something shameful in being well known, above all by people who do not understand you. A great reputation is therefore somehow shameful."

But if he is illustrious, he also remains elusive. We have glimpses of his personality in the notebooks and letters that have been passed down to us, and in anecdotes and conversations recorded by his friends and associates during or just after his lifetime. We have the works of art themselves, which reveal their secrets slowly and reward patient study. Yet we are left with an artist who never

wished to be "understood," in the conventional sense, who spurned attempts to classify him historically, who rejected praise and fame when they were offered to him too easily. He was in the saleroom when his *Dancers Practicing at the Bar* (a gift from the artist to his friend Henri Rouart; see page 174) was auctioned in 1912, for a world-record price of 435,000 francs. When asked if he was disappointed not to share in the vast profit, the artist refused to complain. "I am like the racehorse who wins the Grand Prix," he commented, "I am satisfied with my ration of oats."

In the past twenty years, intensive research has revealed much that we did not know about Degas. We now know, and are fascinated by, how many performances of Ernest Reyer's opera *Sigurd* he attended in the late 1880s and early 1890s (thirty-seven!); we can describe with accuracy the twenty-two states through which his print *After the Bath* evolved in 1879 and 1880; we know more than ever about his techniques and his travels, his friends and his family. But while he is far from unknown, Degas remains elusive, evasive, contradictory, and complex.

Hilaire-Germain-Edgar Degas was born in Paris in 1834, the eldest of Auguste and Célestine De Gas's five children. Both parents were French, but each had been born far away. Auguste was brought up in Naples, where his father, Hilaire Degas, had fled at the time of the French

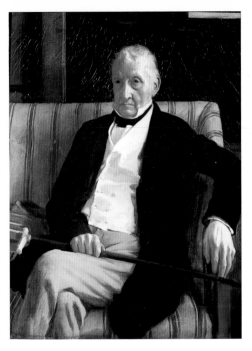

Hilaire Degas, 1857.
Oil on canvas, 20⅞ x 16⅛ in. (53 x 41 cm).
Musée d'Orsay, Paris.

9

Revolution; Célestine Musson was a native of the French-speaking world of New Orleans. In the 1820s Auguste moved to Paris to run a branch of his father's bank. (It was at that time that he began using the pseudo-aristocratic spelling De Gas; his son Edgar returned to the conventional spelling in the 1860s.)

Degas may have first become interested in art through his father, who took him to see important Parisian collections; one of his schoolmates, Paul Valpinçon, was also the son of a great collector. Shortly after high school Degas began copying the old masters at the Louvre and the Bibliothèque Nationale in his self-directed course of study to become a painter. He briefly tried to study law—his father had hopes of a profession for his son—but by 1855 Degas was enrolled at the Ecole des Beaux-Arts. In 1856 he left the Ecole for a three-year study trip in Italy. When he returned to Paris, armed with ambitions of history painting in the style of the old masters, he was tempted by modernity in portraiture and genre painting. During the first half of the 1860s, Degas vacillated between these poles, painting his classically inspired *Young Spartans* (page 37) at the same time that he began the first of his paintings of jockeys and horses (page 126).

One day in 1865, we are told, Degas was in the Louvre, copying a portrait by the Spanish painter Diego

Velázquez. As the story goes, Edouard Manet, then one of the best-known members of the artistic vanguard, noticed Degas, intervened and advised, and the two artists became friends. Manet, of course, was recognized as the painter who most vividly captured in his art the savor of modern Paris, its crowds both high and low, the spirit of a city of splendor and misery. Encouraged by Manet's new realism, Degas embraced Paris with a passion, searching out new and unexplored subjects for his pencil and brush.

Through the 1870s, Degas painted modern life: images of the racecourse, the ballet, cafés, even brothels were his specialties, along with portraits of critics and collectors, artists and writers. He traveled to New Orleans in 1872–73 to visit his brothers, businessmen who had settled there with their families, and the artist discovered fascinating subjects in the New World, such as the office where his family bought and sold cotton (pages 94, 95). On his return to Paris Degas, like many other young painters, grew dissatisfied with the officially-sponsored exhibitions of conventional modern painting. "The realist movement no longer needs to fight with the others," he wrote to the painter James Tissot in 1874, "it already *is*, it *exists,* it must show itself as *something distinct,* there must be a *salon of realists.*"

Plans were already well underway for an exhibition of independent painting—the first of eight such

presentations by the painters who would soon be called the Impressionists. (Degas participated in all but the seventh of these, in 1882.) In general, he was admired by the critics, who saw him as less intransigent than some of the landscape painters in the group. But he soon provoked controversy: in 1881 his sculpture *Little Fourteen-Year-Old Dancer* was a bold realist statement, and at the 1886 exhibition, his suite of awkwardly posed nudes was nothing short of sensational.

The works that Degas exhibited with the Impressionists were created in an astonishing variety of media. In addition to oil paintings on canvas, he made a special place for his works on paper, showing drawings in pencil, chalk, or charcoal, as well as pictures in pastel, gouache, distemper, and his favored *peinture à l'essence,* oil colors thinned with spirits. His versatility in these media was a decision both artistic and practical: a reversal in his family's fortunes in the mid-1870s made it necessary for Degas to sell more of his art; small paintings and works on paper were more easily marketed. In 1877 he exhibited a group of experimental works he called "drawings made with thick ink and then printed" (these are now commonly called "monotypes"). He was inventive in sculpture as well: the *Little Fourteen-Year-Old Dancer* was an alarmingly lifelike wax figure, wearing a miniature dancer's costume, wig, and hair ribbon.

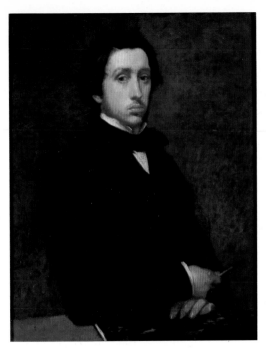

Self-Portrait, 1855.
Oil on canvas, 31⅞ x 25¼ in. (81 x 64 cm).
Musée d'Orsay, Paris.

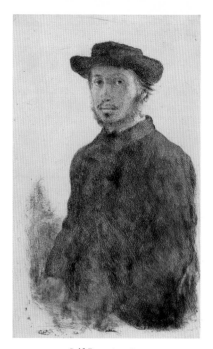

Self-Portrait, 1857.
Etching, 14⅛ x 10¼ in. (36 x 26 cm).
Bibliothèque d'Art et d'Archéologie,
Université de Paris (Fondation Jacques Doucet).

Degas in the studio was like a chef in his kitchen, experimenting with new recipes for piquant mixtures of media, carefully adjusting the dimensions of a work of art to accent its flavor, aiming to delight and surprise his audience with an unexpected color or a radical point of view. He used his notebooks to record his experiments, to jot down the addresses of suppliers, to set forth new recipes for his techniques, or to plan new strategies for working: "Study from all perspectives a face or an object, anything . . . set up tiers all around the room to get used to drawing things from above and below. Only paint things seen in a mirror . . . pose the model on the ground floor and work on the first floor to get used to retaining forms and expressions and to never drawing or painting immediately." In the studio, Degas's memory and imagination conspired to create works with a surprising sense of immediacy, often coming from the artist's distinctive vantage point—near or far from the action, above or below (pages 120, 138, 200).

From our study of the works themselves, and from his own writings, as well as those of his friends and associates, there emerges a picture of Degas as a great manipulator of his materials and his subjects. "Art is the same word as artifice," he said, "that is to say, something deceitful. It must succeed in giving the impression of nature by false means, but it has to look true. Draw a straight line askew,

as long as it gives the impression of being straight!" When the public saw spontaneity in the works of Degas—for Impressionists were commonly thought to work quickly and freely—Degas reacted violently: "I assure you that no art was ever less spontaneous than mine. What I do is the result of reflection and the study of the great masters; of inspiration, spontaneity, temperament—temperament is the word—I know nothing."

Calculating. Deceitful. Reflective. Artificial. These are the words that Degas might have used to describe a great artist. "The artist must live apart, and his private life remain unknown," he once said. Degas was notoriously silent on issues of the heart, and while from youth to old age he had many close friends, his relationships with them often soured, due to his stubbornness and famously foul temper. He disagreed with his lifelong friend, dramatist Ludovic Halévy, over the guilt of Captain Alfred Dreyfus, a Jewish army officer wrongly accused of treason. Although they had been close for years, Degas ultimately wrote to Mme Halévy in 1897 that she should no longer invite him to her home.

If Degas can be accused of cruelty, it must be said that he was at least aware of his harshness. To art dealer and collector Ambroise Vollard, he joked, "If I did not treat people as I do I would never have a minute to myself for work. But I am really timid by nature." To

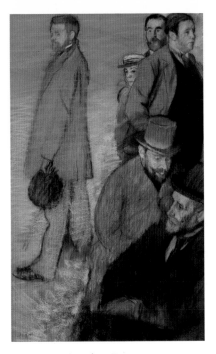

Six Friends at Dieppe, 1885.
Pastel on paper, 45¼ x 28 in. (115 x 71 cm).
Museum of Art, Rhode Island School of Design, Providence.

17

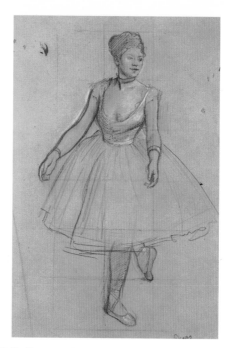

A Ballet Dancer in Position, Three-Quarters Front, c. 1872.
Pencil and white chalk on pink paper, 16⅛ x 11¼ in.
(41 x 28.5 cm). Harvard University Museums,
18 Fogg Art Museum, Cambridge, Massachusetts.

Evariste de Valernes, a minor painter with whom he had been friends since the 1860s, he wrote in 1890:

> I was or I seemed to be hard with everyone through a sort of passion for brutality, which came from my uncertainty and my bad humor. I felt myself so badly equipped, so weak, whereas it seemed to me that my calculations on art were so right. I brooded against the whole world and against myself. I ask your pardon if, beneath the pretext of this damned art, I have wounded your very intelligent and fine spirit, maybe even your heart.

As the century came to a close, the artist was still at work, as strong in his "calculations" as he had been when a young man. But the specter of blindness, which had threatened him since the 1870s, closed in on him. "Since my eyesight has diminished further, my twilight has become more and more lonely and more and more somber. Only the taste for art and the desire to succeed keep me going," he wrote to his sister's family. Although still making art, Degas had periods of ill health and, it seems, depression. Halévy's son, Daniel, went to see the painter in 1904 and was shocked "to see him dressed like a tramp, grown so thin, another man entirely."

Degas went one last time to visit his family in Italy during the autumn of 1906. In 1912 he was forced to abandon the apartment in which he had lived for more than a decade. The move seems to have weakened his will: "Since I moved," he told a friend, "I no longer work. I let everything go. It's amazing how indifferent you get in old age." When he could no longer travel, he rode the omnibus or the tram to the suburbs. He walked the streets of Paris almost daily until, in 1915, his health began to fade seriously. Watched over by his niece, he died in 1917. His friends—some of whom he had not seen in years— buried him in the family tomb at Montmartre cemetery, as the guns of war sounded in the distance.

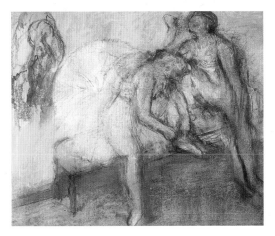

Two Dancers Resting, c. 1910.
Pastel and charcoal on paper, 30¾ x 38⅝ in. (78 x 98 cm).
Musée d'Orsay, Paris.

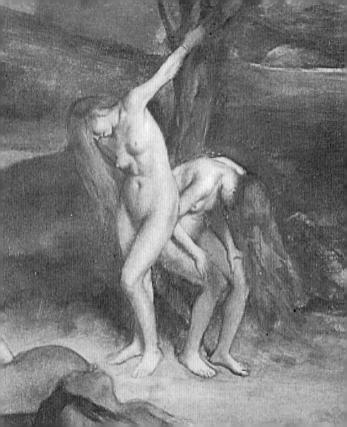

EARLY WORK

In the early spring of 1853, Degas completed his *baccalau-réat* from the Lycée Louis le Grand, and within weeks had registered as a copyist at the Louvre Museum and at the print collection of the great national library. His desire to copy art of the past is the first real evidence of his artistic leanings, before his failed attempt to study law, and before he seriously took up the study of art in 1855. In that year, he passed the entrance examinations for the Ecole des Beaux-Arts, and began there as a student of Louis Lamothe, a conservative painter in the tradition of Jean-Auguste-Dominique Ingres, an artist whom the young Degas (and his father) much admired.

Copies after the old masters, such as his copy of Michelangelo's *Bound Slave* (page 31), alternate with studies after posed models, such as the delicate *Study of a Nude* (page 27) in Degas's paintings and drawings from the 1850s. It was during this influential period of his trav-els in Italy that he would study the giants of Renaissance art and have his first real lessons in how great art was made (page 30). For the young artist at the Ecole or for the student traveler pursuing an independent artistic education, copying was an essential element in the curriculum, the first step toward working from nature. Decades later Degas

still held to this belief, making a copy from Mantegna in the Louvre, and telling Ambroise Vollard that an artist "should copy the masters and re-copy them, and after he has given every evidence of being a good copyist, he might then reasonably be allowed to do a radish, perhaps, from nature."

Degas's notebooks and letters reveal his ever-widening appreciation for the spectrum of artistic accomplishment, for if he began by seeking out the draftsmanship and form of Florentine masters, he soon—under the influence of his friend, the painter Gustave Moreau—began to admire the rich colors of the Venetian Renaissance. It was in Italy, too, that he developed a penchant for introspection and self-doubt that would later be masked by his considerable wit and humor. And he dedicated himself fully to art and its processes. "The best I can do," he wrote to Moreau, "is to study my craft. I could not undertake anything of my own. It takes a bit of patience to pursue the hard path I have chosen . . . I remember the conversation we had in Florence about the sadness that is the lot of those involved with art. . . . It increases with age and progress and youth doesn't exist any more to console you with a few illusions and hopes."

On his return to Paris from his second sojourn in Italy, Degas began to apply the lessons and techniques he had learned, embarking on *The Daughter of Jephthah* (page 33),

the first in a group of complicated, many-figured paintings of historical subjects—the others were *Semiramis Building Babylon* (page 35), *Young Spartans* (page 37), and *Scene of War in the Middle Ages* (detail, page 22, and page 41). He worked on these paintings long and hard, producing elaborate compositional studies and many drawings of individual figures that are among the most beautiful and moving drawings of his career. The paintings themselves, however, were often left unfinished, or were spoiled by his overworking, and only one of them, *Scene of War,* was exhibited to the public at the official Salon. But Degas's early work does not stand in isolation from the main body of his art: the drawings of nude women in distinctive and sometimes disturbing poses that Degas made for *Scene of War* brought the artist close to the themes of bathers and brothel-women that he would elaborate on in the 1870s and 1880s. "Oh Giotto!" Degas wrote, "Let me see Paris, and you, Paris, let me see Giotto!"

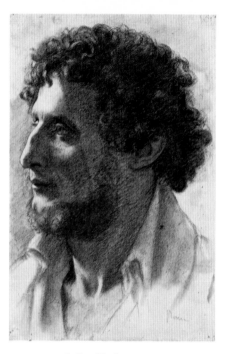

Italian Head, c. 1856.
Charcoal on ivory paper, 15⅛ x 10¼ in. (38.4 x 26 cm).
The Art Institute of Chicago.

Study of a Nude, 1856.
Pencil on pink paper, 11⅛ x 8¼ in. (28.2 x 21 cm).
W. M. Brady & Co., New York.

Roman Beggar Woman, 1857.
Oil on canvas, 39½ x 29⅝ in. (100.3 x 75.2 cm).
Birmingham Museums and Art Gallery, England.

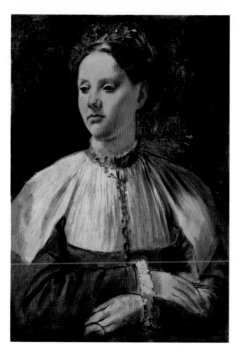

Portrait of a Woman, after Pontormo, 1850s.
Oil on canvas, 25 x 17½ in. (63.5 x 44.5 cm).
National Gallery of Canada, Ottawa.

Copy after Botticelli's "Birth of Venus," c. 1859.
Pencil on paper, 11⅞ x 8⅞ in. (30 x 22.5 cm).
Private collection.

The Bound Slave, after Michelangelo, c. 1859.
Pencil on paper, 13 x 9 in. (33 x 22.9 cm).
Private collection.

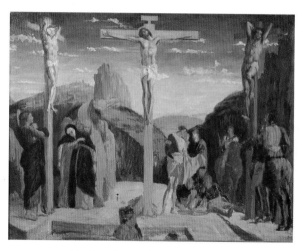

The Crucifixion, after Mantegna, 1861.
Oil on canvas, 27⅛ x 36⅜ in. (69 x 92.5 cm).
Musée des Beaux-Arts, Tours, France.

The Daughter of Jephthah, c. 1859–61.
Oil on canvas, 77 x 115½ in. (195.5 x 293.5 cm).
Smith College Museum of Art, Amherst, Massachusetts.

Standing Woman, study for "Semiramis Building Babylon,"
c. 1860–62. Pencil with watercolor and gouache on
blue paper, 11½ x 8⅝ in. (29.1 x 21.9 cm).
34 Cabinet des Dessins, Musée du Louvre (Orsay), Paris.

Semiramis Building Babylon, c. 1860–62.
Oil on canvas, 59 x 101⅝ in. (150 x 258 cm).
Musée d'Orsay, Paris.

The Rape of the Sabines, after Nicolas Poussin, c. 1861–63.
Oil on canvas, 59 x 81½ in. (149.9 x 207 cm).
Norton Simon Art Foundation, Pasadena, California.

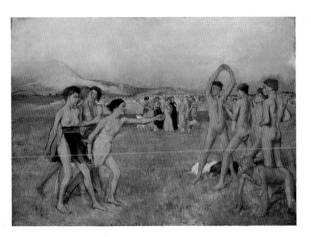

Young Spartans, c. 1860–62, reworked later.
Oil on canvas, 42⅞ x 61 in. (109 x 155 cm).
National Gallery, London.

Nude Woman Seated, study for "Scene of War in the Middle Ages,"
c. 1863–65. Pencil and black crayon on paper,
12¼ x 10⅞ in. (31.1 x 27.6 cm).
38 Cabinet des Dessins, Musée du Louvre (Orsay), Paris.

Seminude Woman Lying on Her Back, study for
"Scene of War in the Middle Ages," c. 1863–65.
Pencil on paper, 9 x 14 in. (22.8 x 35.6 cm).
Cabinet des Dessins, Musée du Louvre (Orsay), Paris. 39

Standing Nude Woman, study for "Scene of War in the Middle Ages," c. 1863–65. Pencil heightened with white on paper, 14 x 19 in. (35.6 x 22.8 cm).
40 Cabinet des Dessins, Musée du Louvre (Orsay), Paris.

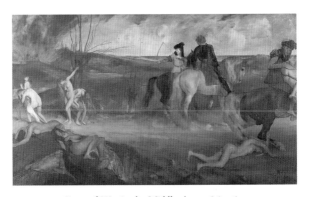

Scene of War in the Middle Ages, 1863–65.
Oil on paper joined and mounted on canvas,
31⅞ x 57⅞ in. (81 x 147 cm). Musée d'Orsay, Paris.

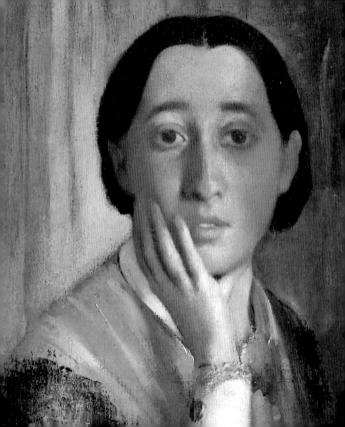

PORTRAITS

In 1858 Auguste Degas, the painter's father, wrote to Italy to console his son, who had complained of boredom at doing portraits. The elder Degas knew that portraiture was a means by which many a young artist could make a living. "You must overcome this later on," the father wrote, "for portraiture will be one of the finest jewels in your crown." The elder Degas was right, of course, that his son would prove to be one of history's great masters of portraiture, but he surely did not suspect that Edgar would hardly ever paint a likeness for money, nor that his son would, in the process of adapting the portrait to his artistic needs, reinvent the genre.

Degas had made brilliant portraits of his friends and family since the 1850s, as his sensitive drawings and paintings of his siblings show. His early interest in likeness and in the exploration of physiognomy (page 56), pose (page 61), and gesture (pages 50–51) combined in the 1860s to inspire striking images of his intimate circle—Léon Bonnat, Edouard Manet (page 54), or his sister Thérèse and her husband Edmondo Morbilli (pages 52 and 53). The majority of Degas's portraits, however, date between 1865 and 1885—that is, from the awakening of his interest in the peculiarities of modern life in Paris to the breakup of the Impressionist exhibitions in 1886.

The greatest of Degas's early portraits is undoubtedly the nearly life-size image known as *The Bellelli Family* (page 49), depicting his father's sister, Laure; his cousins, Giulia and Giovanna; and their father, Gennaro Bellelli. Begun in Florence and finished later in Paris, the painting shows not only Degas's great ability to obtain a likeness—evolved through careful study of details (pages 46, 47, 48)—but also reveals his genius at suggesting complex, ambiguous psychological relationships through the poses of his sitters and the atmosphere that pervades the composition.

For Degas, a portrait had to be more than a likeness: it had to capture a sense of the individual on more than one level. In one of his notebooks he wrote that he wanted to reanimate an academic exercise, the expressive head, by making it "a study of modern feelings." He wanted to "make portraits of people in typical, familiar poses, being sure above all to give their faces the same kind of expression as their bodies. Thus if laughter typifies an individual, make her laugh. There are, of course, feelings that one cannot convey, out of propriety, as portraits are not intended for us painters alone."

"How many nuances to put in?" Degas wondered. As his career developed, he decided to make portraits of people in settings that could be recognized as befitting their occupation and social station. His uncle and brothers were shown in their New Orleans cotton office (see page 95),

writers Diego Martelli and Edmond Duranty were posed by their cluttered desks (pages 70–73), and Hélène Rouart is shown in the art-filled study of her father (page 79). These portraits, from the years of Degas's profound immersion in subjects drawn from the world around him, are sometimes as much genre paintings as they are likenesses—Degas did, in fact, make the portrait into the embodiment of "modern feelings."

Giovanna Bellelli, study for "The Family Portrait," 1858–59.
Black chalk on pink paper, 12⅞ x 9⅜ in. (32.6 x 23.8 cm).
Cabinet des Dessins, Musée du Louvre (Orsay), Paris.

Giulia Bellelli, study for "The Family Portrait," 1858–59. Black chalk and gray wash on paper, 9¼ x 7¾ in. (23.4 x 19.6 cm). Cabinet des Dessins, Musée du Louvre (Orsay), Paris.

47

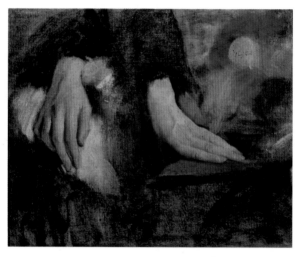

Study of Hands, for "The Family Portrait," 1858–59.
Oil on canvas, 15 x 18⅛ in. (38 x 46 cm).
Musée d'Orsay, Paris.

48

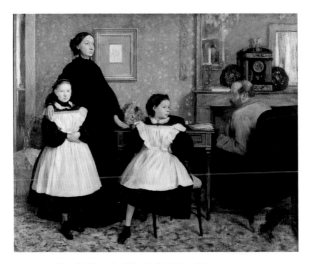

Family Portrait (The Bellelli Family), 1858–67.
Oil on canvas, 78¾ x 93⅜ in. (200 x 250 cm).
Musée d'Orsay, Paris.

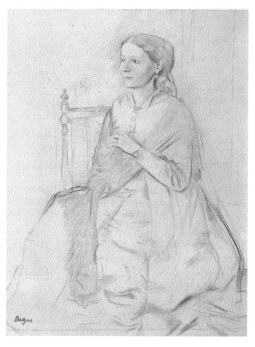

Madame Julie Burtey, 1863–66. Pencil and white chalk on paper, 14¼ x 10¾ in. (36.2 x 27.3 cm). Harvard University Museums, Fogg Art Museum, Cambridge, Massachusetts.

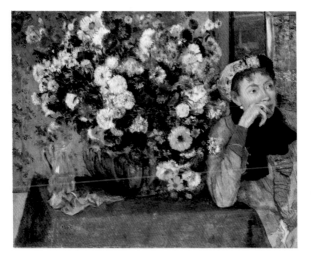

Woman Leaning near a Vase of Flowers (Mme. Paul Valpinçon),
1865. Oil on canvas, 29 x 36½ in. (73.7 x 92.7 cm).
The Metropolitan Museum of Art, New York.

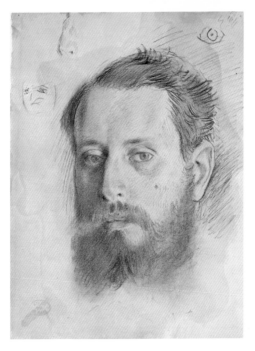

Edmondo Morbilli, study for "M. and Mme. Edmondo Morbilli,"
c. 1865. Pencil on paper, 12½ x 9 in. (31.7 x 22.8 cm).
Museum of Fine Arts, Boston.

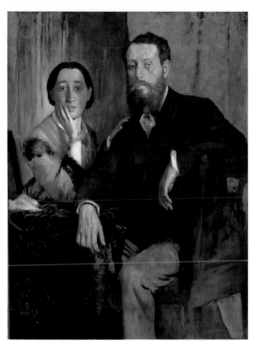

M. and Mme. Edmondo Morbilli, c. 1865.
Oil on canvas, 45⅞ x 34¾ in. (116.5 x 88.3 cm).
Museum of Fine Arts, Boston.

Edouard Manet, c. 1866–68.
Pencil and ink on paper, 13¾ x 7¾ in. (35 x 20 cm).
Musée d'Orsay, Paris.

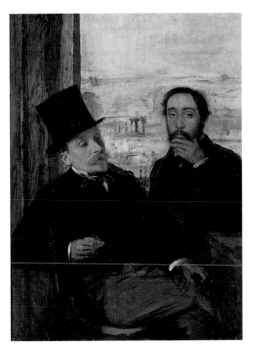

Self-Portrait with Evariste de Valernes, c. 1865.
Oil on canvas, 45⅝ x 35 in. (116 x 89 cm).
Musée d'Orsay, Paris.

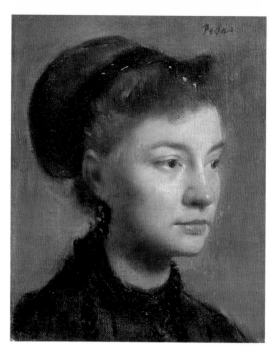

Portrait of a Young Woman, c. 1867.
Oil on canvas, 10⅝ x 8⅝ in. (27 x 22 cm).
Musée d'Orsay, Paris.

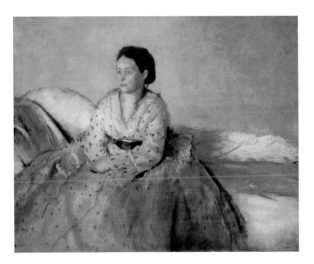

Estelle Musson Degas, 1872–73.
Oil on canvas, 28¾ x 36¼ in. (73 x 92 cm).
National Gallery of Art, Washington, D.C.

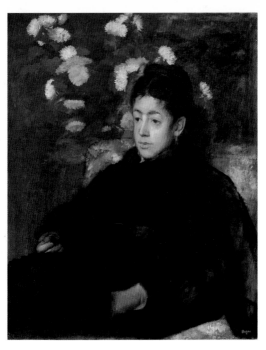

Mademoiselle Malo, c. 1877.
Oil on canvas, 31⅞ x 25⅛ in. (81.1 x 65.1 cm).
National Gallery of Art, Washington, D.C.

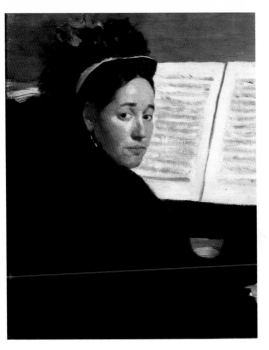

Mlle. Dihau at the Piano, c. 1870–72.
Oil on canvas, 17¾ x 12¾ in. (45 x 32.5 cm).
Musée d'Orsay, Paris.

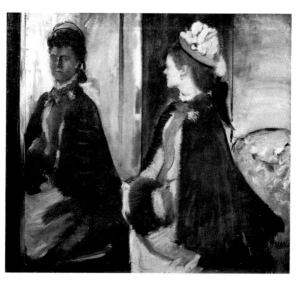

Mme. Jeantaud before a Mirror, c. 1875.
Oil on canvas, 29⅛ x 33½ in. (70 x 84 cm).
Musée d'Orsay, Paris.

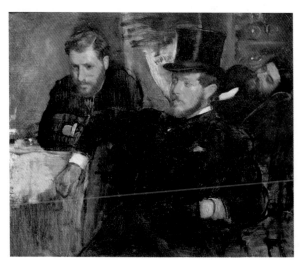

Jeantaud, Linet, and Lainé, 1871.
Oil on canvas, 15 x 18⅛ in. (38 x 46 cm).
Musée d'Orsay, Paris.

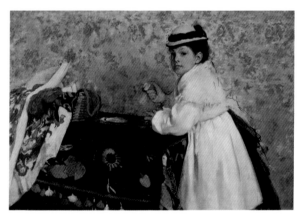

Hortense Valpinçon, 1871.
Oil on canvas, 29⅞ x 43⅝ in. (76 x 110.8 cm).
The Minneapolis Institute of Arts.

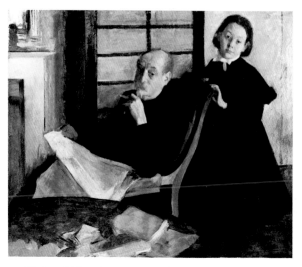

Uncle and Niece (Henri Degas and His Niece Lucie Degas),
c. 1876. Oil on canvas, 39¼ x 47¼ in. (99.8 x 119.9 cm).
The Art Institute of Chicago.

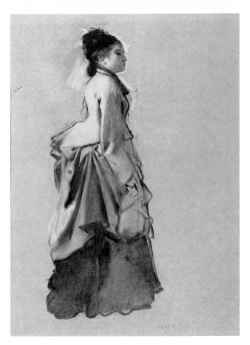

A Young Woman in Street Costume, c. 1872.
Essence or gouache on pink paper, 12¾ x 9⅞ in.
(32.5 x 25 cm). Harvard University Art Museums,
Fogg Art Museum, Cambridge, Massachusetts.

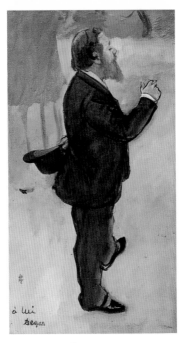

Carlo Pellegrini, c. 1876–77.
Watercolor and pastel on paper, 24 x 13 in. (61 x 33 cm).
The Tate Gallery, London.

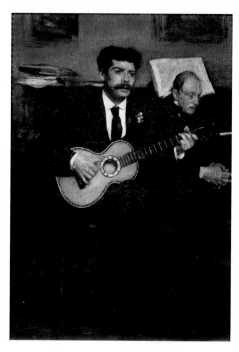

Lorenzo Pagans and Auguste De Gas, c. 1871-72.
Oil on canvas, 21¼ x 15¾ in. (54 x 40 cm).
Musée d'Orsay, Paris.

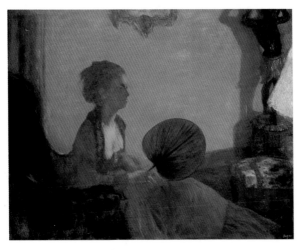

Mme. Camus, c. 1870.
Oil on canvas, 28⅝ x 36¼ in. (72.7 x 92.1 cm).
National Gallery of Art, Washington, D.C.

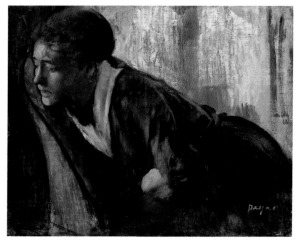

Melancholy, late 1860s.
Oil on canvas, 7½ x 9¾ in. (19 x 24.7 cm).
Phillips Collection, Washington, D.C.

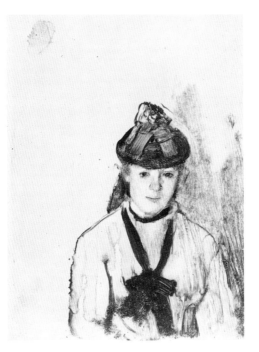

Ellen André, 1876.
Monotype in black ink on paper, 8⁷⁄₁₆ x 6⁵⁄₁₆ in.
(21.5 x 16 cm). The Art Institute of Chicago.

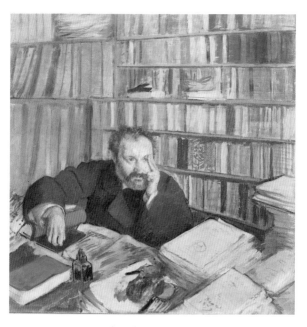

Edmond Duranty, 1879.
Pastel and distemper, 39⅝ x 39½ in. (100.9 x 100.3 cm).
The Burrell Collection, Glasgow.

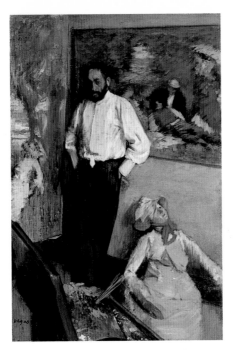

Portrait of a Painter in His Studio, c. 1878.
Oil on canvas, 15¾ x 11 in. (47 x 31.8 cm).
Calouste Gulbenkian Museum, Lisbon.

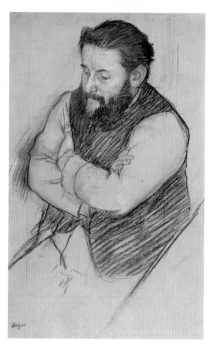

Diego Martelli, 1879. Black and white chalk on paper,
17¾ x 11¼ in. (45 x 28.6 cm). Harvard University Art
Museums, Fogg Art Museum, Cambridge, Massachusetts.

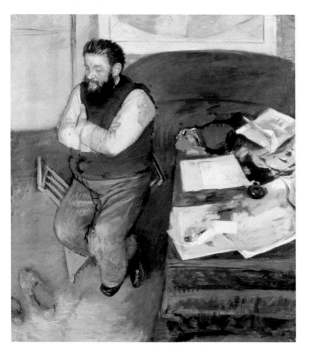

Diego Martelli, 1879.
Oil on canvas, 43½ x 39¾ in. (110 x 100 cm).
National Gallery of Scotland, Edinburgh.

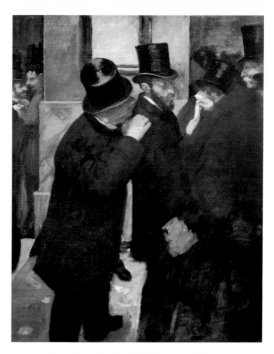

Portraits at the Stock Exchange, 1878–79.
Oil on canvas, 39⅜ x 32¼ in. (100 x 82 cm).
Musée d'Orsay, Paris.

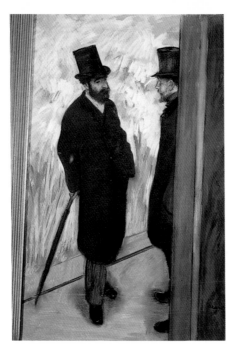

Portrait of Friends in the Wings (Ludovic Halévy and Albert Cavé),
1879. Pastel on paper, 31⅛ x 21⅝ in. (79 x 55 cm).
Musée d'Orsay, Paris.

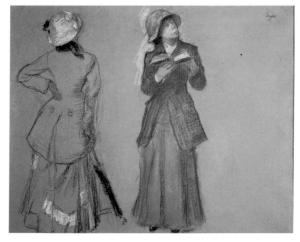

Two Studies of Mary Cassatt or Ellen André at the Louvre, c. 1879.
Charcoal and pastel on gray paper, 18¾ x 24¾ in.
(47.6 x 62.9 cm). Private collection.

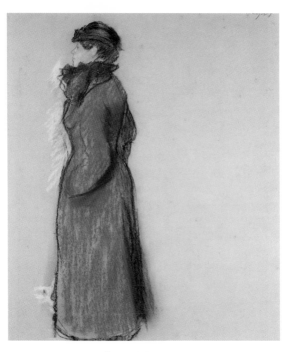

Ellen André, c. 1879.
Pastel on paper, 19⅛ x 16½ in. (48.5 x 42 cm).
Private collection.

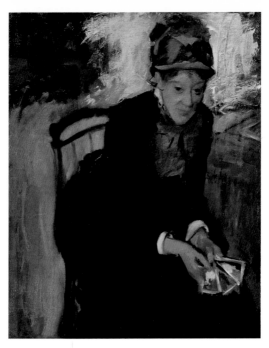

Mary Cassatt, c. 1884.
Oil on canvas, 28⅛ x 23⅛ in. (71.5 x 58.7 cm). The National
Portrait Gallery, Smithsonian Institution, Washington, D.C.

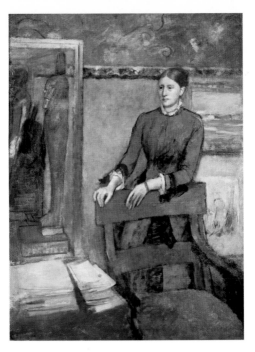

Hélène Rouart, 1886.
Oil on canvas, 63⅜ x 47¼ in. (161 x 120 cm).
National Gallery, London.

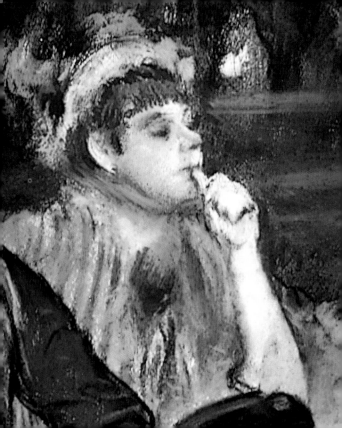

MODERN LIFE

From his early days in Italy, Degas had been an enthusiastic student of modern characters and situations. He recorded in his notebooks the appearance and manner of people he encountered on his travels, often with a wry wit and sense of caricature. From the middle years of the 1860s, as his portraits began more and more to be infused with an element of narrative, Degas turned increasingly to subject matter drawn from modern life. Following in the steps of Gustave Courbet, who had led the Realist movement of the 1850s, and inspired by his friend Edouard Manet, who was proving himself an estimable painter of modern life, Degas set out to explore the avenues of the new Paris.

Walking through Paris, by day or night, Degas encountered subjects that suited his ironic temperament and his keen taste for the telling slice of life. Of course, he was to make his most enduring mark as the painter of dancers, but he was ever on the lookout for new ideas. He delighted in observing the manners of Parisians of all classes at the café and the café-concert (opposite and pages 101–103). From memory, he would record their expressions in albums that he kept for after-dinner drawing at the home of a friend. For a painting called *In a Café* (page 100), he posed an actress friend, Ellen André (see pages 69 and 77), as a dis-

solute drinker of absinthe. He looked through half-opened doors at actresses and singers in their dressing rooms and observed the curious shadows cast on their faces from footlights and glass-globed chandeliers.

As he planned a series of black-and-white prints for a magazine he hoped to publish—it was to be called *Jour et nuit* (literally "day and night")—he scribbled related thoughts in a journal. He planned a "series on instruments and instrumentalists, their forms, the twisting of the hands and arms and neck of a violinist"; another series might be done "on smoke—smoker's smoke, pipes, cigarettes, cigars—smoke from locomotives, from tall factory chimneys, from steam boats"; another could be devoted to "bread—series on baker's boys, seen in the cellar itself, or through the basement windows from the street . . . studies in color of the yellows, pinks, grays, whites of bread."

With a clever eye on the art market, Degas was searching for subjects that would bring him recognition, and at the same time he seized on ideas that allowed him to display his skills as a draftsman and a colorist. As far as we know, Degas never finished paintings or pastels of bread bakers and pastry cooks, but we can imagine what they might have been like when we look at his paintings and pastels of milliners and laundresses (pages 113–117 and 118–119). In these pictures, working women are shown with the accessories of their trades—heavily

starched shirts or gaudily decorated hats. Their profes-
sional gestures, and the habits of their clients, are cap-
tured by Degas's keenly observant drawing, while the
atmosphere of the laundry or the millinery shop is sug-
gested by the delicious range of hues and tones at his
command, by the curious arrangement of space, and
by the carefully asymmetrical cropping of the figures.
For Degas, it was not enough that his subject should
be novel—the way in which it was presented had to be
thoroughly modern, too.

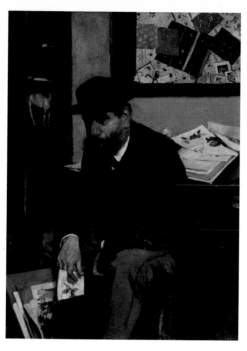

The Collector of Prints, 1866.
Oil on canvas, 20⅞ x 15¾ in. (53 x 40 cm).
The Metropolitan Museum of Art, New York.

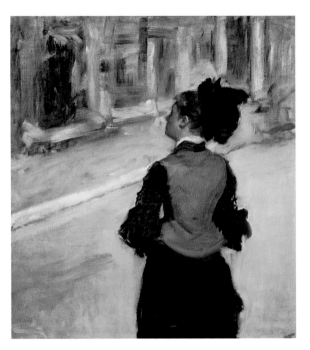

The Visit to the Museum, c. 1885.
Oil on canvas, 32 x 29¾ in. (81.3 x 75.6 cm).
National Gallery of Art, Washington, D.C.

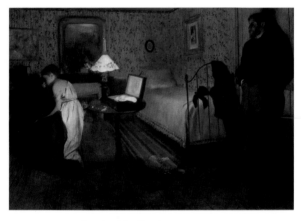

Interior (The Rape), c. 1868–69.
Oil on canvas, 31⅞ x 45⅝ in. (81 x 116 cm).
Philadelphia Museum of Art.

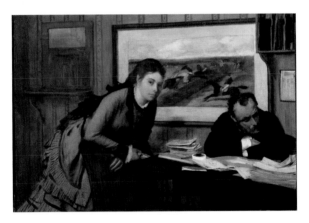

Sulking, c. 1869–71.
Oil on canvas, 12¾ x 18¼ in. (32.4 x 46.4 cm).
The Metropolitan Museum of Art, New York.

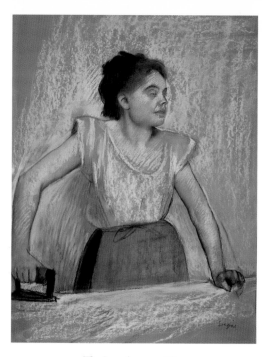

The Laundress, c. 1869.
Pastel, charcoal, and white chalk on paper,
29⅛ x 24 in. (74 x 61 cm). Musée d'Orsay, Paris.

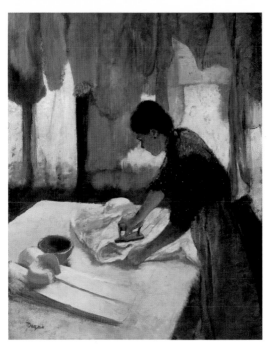

Woman Ironing, c. 1876–c. 1887.
Oil on canvas, 32 x 26 in. (81.3 x 66 cm).
National Gallery of Art, Washington, D.C.

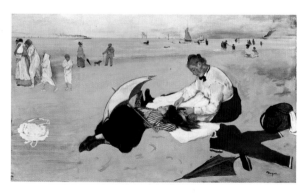

Beach Scene c. 1869.
Essence on paper mounted on canvas, 18½ x 32½ in.
(47 x 82.6 cm). National Gallery, London.

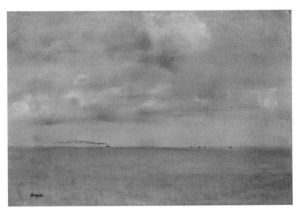

Seascape, 1869.
Pastel on paper, 12⅜ x 18½ in. (31.4 x 46.9 cm).
Musée d'Orsay, Paris.

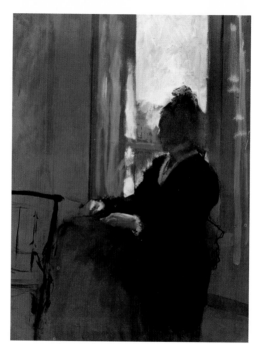

Woman at a Window, 1871–72. Essence on tan wove paper mounted on linen, 24⅛ x 18⅛ in. (61.3 x 45.9 cm). The Courtauld Institute Galleries, London.

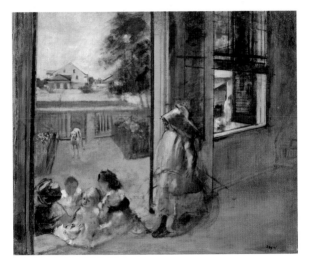

Children on a Doorstep (New Orleans), 1872.
Oil on canvas, 23⅝ x 29½ in. (60 x 75 cm).
Ordrupgaardsamlingen, Copenhagen, Denmark.

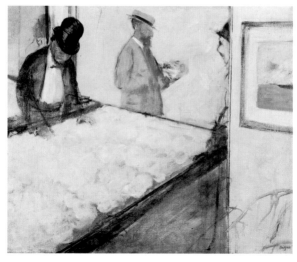

Cotton Merchants in New Orleans, 1873. Oil on canvas,
23⅝ x 28¾ in. (60 x 73 cm). Harvard University Art
Museums, Fogg Art Museum, Cambridge, Massachusetts.

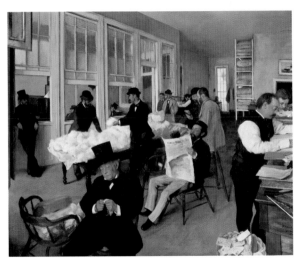

Portraits in an Office, New Orleans, 1873.
Oil on canvas, 28¾ x 36¼ in. (73 x 92 cm).
Musée des Beaux-Arts, Pau, France.

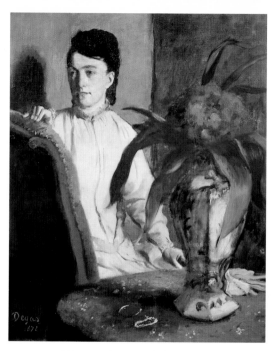

Woman with a Vase of Flowers, 1872.
Oil on canvas, 25⅝ x 13⅜ in. (65 x 34 cm).
Musée d'Orsay, Paris.

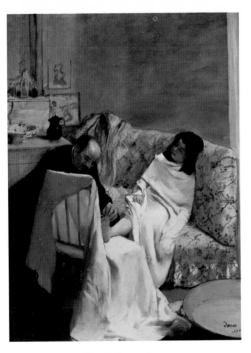

The Pedicure, 1873.
Essence on paper mounted on canvas,
24 x 18⅛ in. (61 x 46 cm). Musée d'Orsay, Paris.

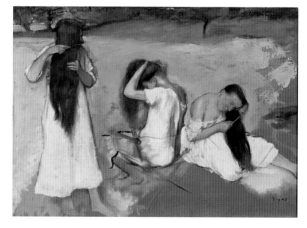

Women Combing Their Hair, c. 1875. Essence on paper,
mounted on canvas, 12¼ x 18⅛ in. (32.3 x 46 cm).
The Phillips Collection, Washington, D.C.

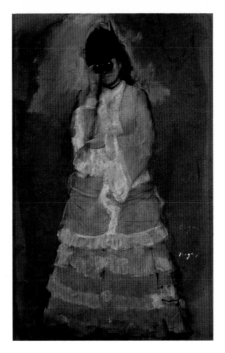

Woman Looking Through Field Glasses, c. 1866.
Pencil and essence on paper, 12¼ x 7½ in. (31 x 19 cm).
The Burrell Collection, Glasgow.

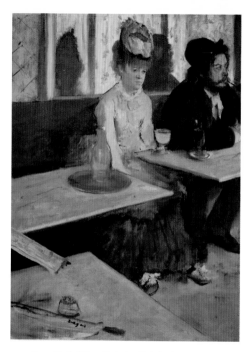

In a Café (The Absinthe Drinker), 1875–76.
Oil on canvas, 36¼ x 26¾ in. (92 x 68 cm).
Musée d'Orsay, Paris.

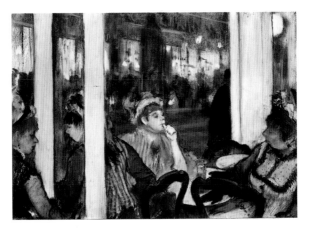

Women on the Terrace of a Café in the Evening, 1877.
Pastel over monotype on paper, 16¼ x 23⅝ in. (41 x 60 cm).
Musée d'Orsay, Paris.

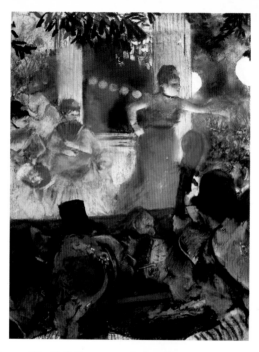

The Café-Concert aux Ambassadeurs, 1876–77.
Pastel over monotype on paper, 14³⁄₁₆ x 11 in. (36 x 28 cm).
Musée des Beaux Arts, Lyons, France.

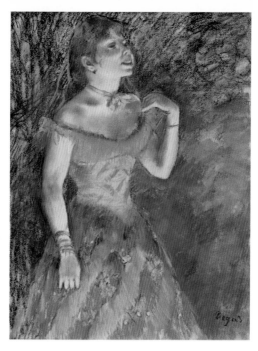

The Singer in Green, c. 1884.
Pastel on blue paper, 23¾ x 18¼ in. (60.3 x 46.3 cm).
The Metropolitan Museum of Art, New York.

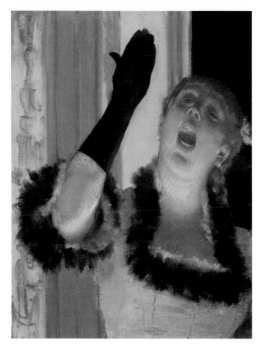

Singer with a Glove, c. 1878. Pastel on canvas, 20⅞ x 16⅛ in.
(53 x 41 cm). Harvard University Art Museums,
Fogg Art Museum, Cambridge, Massachusetts.

Actresses in Their Dressing Room, 1879–85.
Pastel over etching on paper, 6½ x 9 in. (16.5 x 22.9 cm).
Private collection.

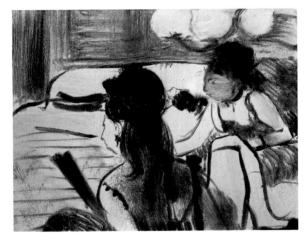

Brothel, c. 1879. Monotype in black ink on paper, 6¼ x 8⅜ in.
(16.1 x 21.4 cm). Bibliothèque d'Art et d'Archéologie,
Université de Paris (Fondation Jacques Doucet).

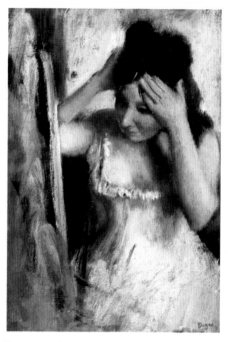

Woman Combing Her Hair Before a Mirror, c. 1877.
Oil on canvas, 15½ x 12½ in. (39.4 x 31.8 cm).
Norton Simon Art Foundation, Pasadena, California.

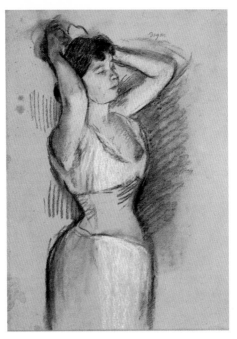

Woman Combing Her Hair, c. 1885.
Black and white chalks and pastel on paper, 23 x 16⅞ in.
(58.5 x 43 cm). The Fine Arts Museums of San Francisco,
Achenbach Foundation for the Graphic Arts.

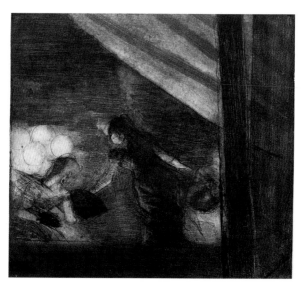

At the Café des Ambassadeurs, 1879–80.
Etching, 10⅞ x 11⅝ in. (26.5 x 29.5 cm).
Bibliothèque Nationale, Paris.

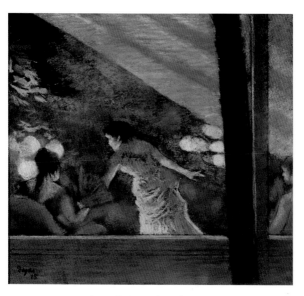

At the Café des Ambassadeurs, 1885.
Pastel over etching on paper, 10⅞ x 11⅝ in. (26.5 x 29.5 cm).
Musée d'Orsay, Paris.

Lady with a Parasol, c. 1876–80.
Oil on canvas, 29½ x 33½ in. (75 x 85 cm).
The Courtauld Institute Galleries, London.

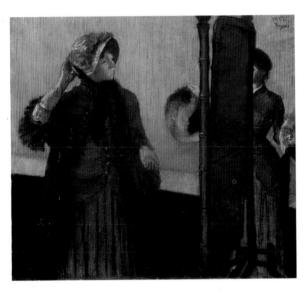

At the Milliner's, 1882.
Pastel on paper, 29¾ x 33¾ in. (75.6 x 85.7 cm).
The Metropolitan Museum of Art, New York.

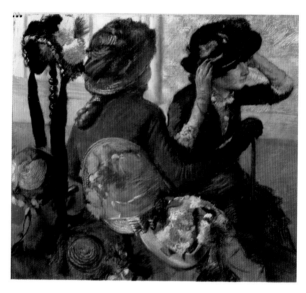

At the Milliner's, 1882.
Pastel on paper, 29⅞ x 33⅜ in. (75.9 x 84.8 cm).
Colleccion Thyssen-Bornemisza, Madrid.

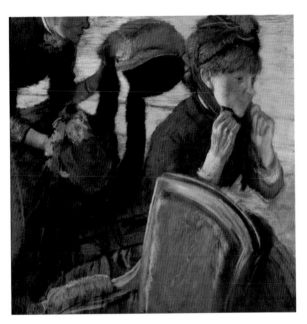

At the Milliner's, c. 1882.
Pastel on paper, 26⅜ x 26⅜ in. (67 x 67 cm).
The Museum of Modern Art, New York.

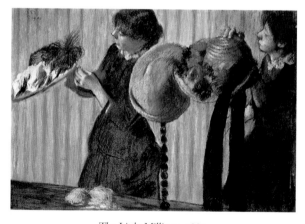

The Little Milliners, 1882.
Pastel on paper, 19 x 27 in. (48.3 x 68.6 cm).
The Nelson-Atkins Museum of Art, Kansas City, Missouri.

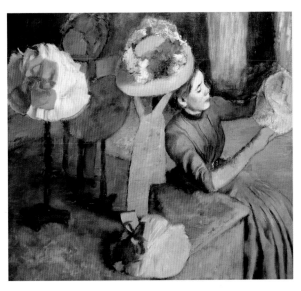

The Millinery Shop, 1882–86.
Oil on canvas, 39⅛ x 43½ in. (100 x 110.7 cm).
The Art Institute of Chicago.

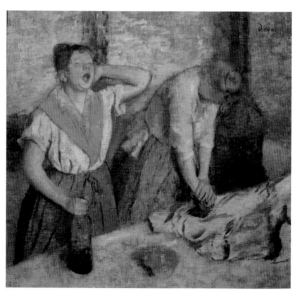

Women Ironing, c. 1884–86.
Oil on canvas, 30 x 31⅞ in. (76 x 81 cm).
Musée d'Orsay, Paris.

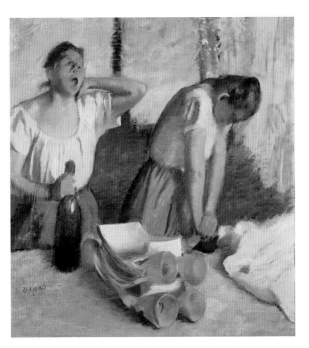

The Ironers, c. 1884–85.
Oil on canvas, 32⅜ x 29¾ in. (82.2 x 75.6 cm).
Norton Simon Art Foundation, Pasadena, California.

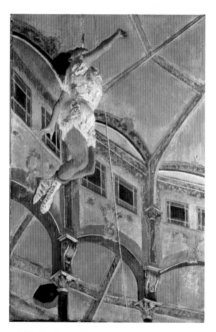

Miss La La at the Cirque Fernando, 1879.
Oil on canvas, 46 x 30½ in. (116 x 77.5 cm).
National Gallery, London.

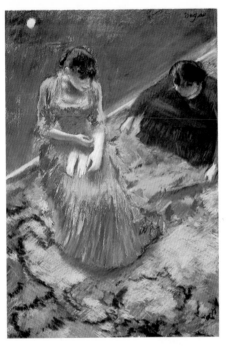

Before the Curtain Call, c. 1890.
Pastel on paper, 20⅛ x 13⅜ in. (51 x 34 cm).
Wadsworth Atheneum, Hartford, Connecticut.

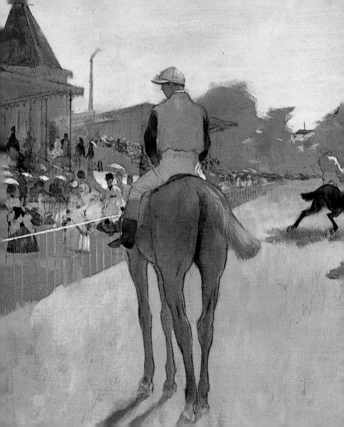

JOCKEYS AND HORSES

Of all the Impressionists, Degas is the artist least identified with painting the out-of-doors, with landscape painting. "You know what I think of people who work out in the open," he told Ambroise Vollard. "If I were the government I would have a special brigade of gendarmes to keep an eye on artists who paint landscapes from nature." In part, his apparent lack of interest in landscape may have stemmed from the eye strain he suffered being in bright light. "The weather here is fine," he wrote to a friend from the seashore, "but more Monet than my eyes can stand!"

From the earliest years of his career, however, Degas experimented with landscape subjects, and at intervals pursued pure landscape with particular interest—even working outdoors. But the theme of the racecourse, with its horses, jockeys, and occasional attendants set against the landscape of France, was a favored subject for Degas's brush, beginning in the early 1860s and lasting until the end of the century. Despite this continuity, the landscapes around Degas's horses and riders vary considerably over the decades. In the 1860s and 1870s, smokestacks sometimes rise on the horizon, but by the 1880s even such ambiguous references to specific places vanish, replaced by generalized rolling hills and lines of trees.

His visits to the Normandy countryside near the Haras-du-Pin, where he stayed at the home of his friends the Valpinçons, familiarized Degas with the traditions of horse breeding and racing. The earliest of his equestrian landscapes derive from English models (page 127). By the mid-1860s, however, with works like *Racehorses before the Stands* (detail, page 122, and page 129), he left behind the conventions of sporting art. In keeping with his acute awareness of modern spectacle, Degas's views of racing in suburban Paris place the jockeys and their steeds against the background of a fashionable audience seated in the grandstands—much as his images of the ballet or the café-concert would later, in the 1870s, depict the performer and her audience. On the other hand, when he showed his friends the Valpinçons in *At the Races in the Countryside* (page 134), he posed the audience with its back to the distant action of the race, which itself, in turn, served as an unusual, if appropriate, background for a family portrait.

Although he learned a great deal about the proper movement of horses from the action photographs of Eadweard Muybridge, the mechanics of racing were only rarely stressed by Degas; when compared to his depictions of Parisian professions, his paintings and pastels of horses and jockeys are markedly non-specific. Degas generally focuses on moments of relative calm on the course. Horse

and rider are shown in review, parading to the start, or returning from the finish; occasionally he shows the animals bunched together before the start of a race. Grouped in diagonal lines penetrating the picture space, or arranged in a frieze parallel to the picture plane, the horses are posed as carefully as any line of dancers waiting to bow. "A painting is above all a product of the artist's imagination," Degas believed, "it must never be a copy. If . . . he wants to add two or three touches from nature, of course it doesn't spoil anything. But the air one sees in the paintings of the masters is not the air one breathes."

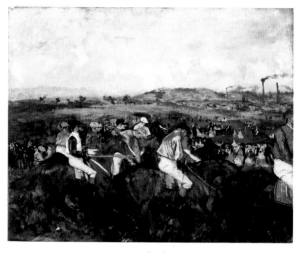

The Gentlemen's Race: Before the Start, c. 1862.
Oil on canvas, 18⅞ x 24 in. (48 x 61 cm).
Musée d'Orsay, Paris.

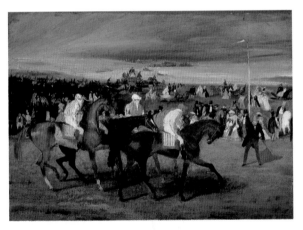

At the Races: The Start, c. 1860–62. Oil on canvas,
12⅝ x 18⅛ in. (32 x 46 cm). Harvard University Museums,
Fogg Art Museum, Cambridge, Massachusetts.

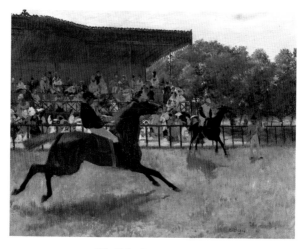

The False Start, 1866–68.
Oil on panel, 12⅝ x 15¾ in. (32 x 40 cm).
Yale University Art Gallery, New Haven, Connecticut.

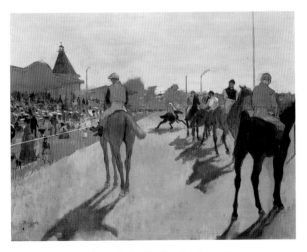

Racehorses before the Stands, 1866–68.
Essence on paper mounted on canvas, 18⅛ x 24 in.
(46 x 61 cm). Musée d'Orsay, Paris.

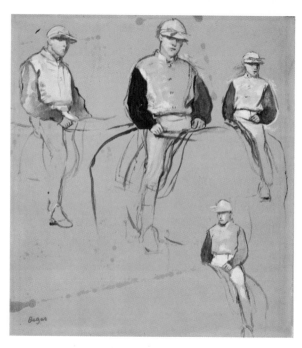

Four Studies of a Jockey, c. 1866–68.
Essence on tan paper, 12⅝ x 11⅝ in. (32 x 29.5 cm).
Private collection.

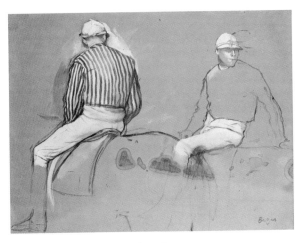

Two Studies of a Jockey, 1866–68.
Essence on tan paper, 9⅛ x 12¼ in. (23.2 x 31 cm).
Private collection.

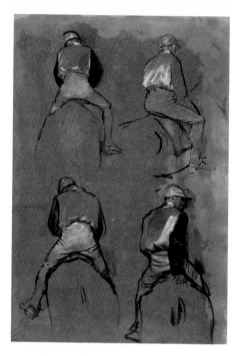

Four Studies of a Jockey, c. 1866–68.
Essence on oiled paper, 17¾ x 12⅜ in. (45 x 31.5 cm).
The Art Institute of Chicago.

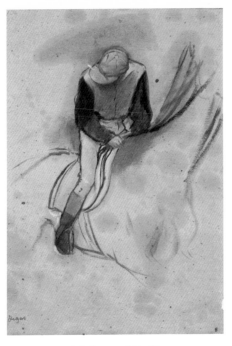

A Jockey, c. 1866–68.
Essence on oiled paper, 13⅝ x 9⅝ in. (34.5 x 24.5 cm).
Private collection.

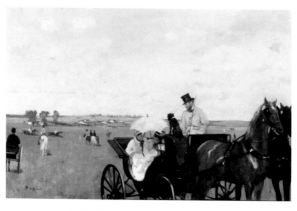

At the Races in the Countryside, 1869.
Oil on canvas, 14⅜ x 22 in. (36.5 x 55.9 cm).
Museum of Fine Arts, Boston.

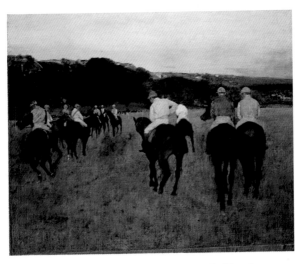

Racehorses at Longchamp, 1871, reworked later?
Oil on canvas, 13⅜ x 16½ in. (34.1 x 41.8 cm).
Museum of Fine Arts, Boston.

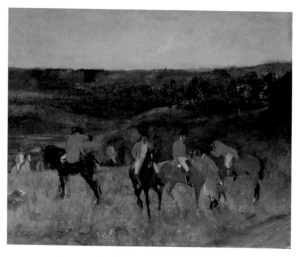

Leaving for the Hunt, 1863–65 and 1873.
Oil on canvas, 26¾ x 34⅞ in. (68 x 88.5 cm).
Private collection.

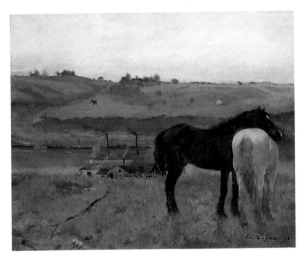

Horses in a Meadow, 1871.
Oil on canvas, 12⅝ x 15¾ in. (32 x 40 cm).
National Gallery of Art, Washington, D.C.

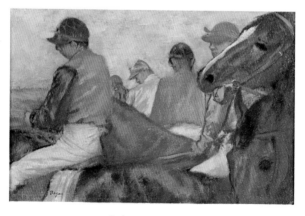

Jockeys, c. 1881–85.
Oil on canvas, 10⅛ x 15¹¹⁄₁₆ in. (26.4 x 39.9 cm).
Yale University Art Gallery, New Haven, Connecticut.

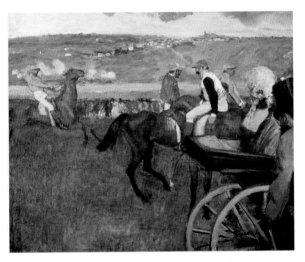

The Racecourse, Amateur Jockeys, 1876 and 1887.
Oil on canvas, 26 x 31⅞ in. (66 x 81 cm).
Musée d'Orsay, Paris.

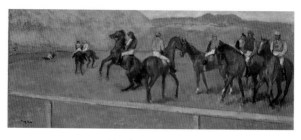

Racehorses, c. 1880.
Oil on canvas, 15⅜ x 35 in. (39 x 89 cm).
Emil G. Bührle Foundation Collection, Zurich.

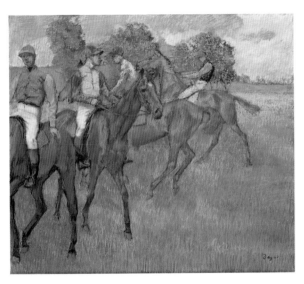

Race Horses, c. 1884.
Pastel on paper, 22⅝ x 25¾ in. (57.5 x 65.4 cm).
Cleveland Museum of Art.

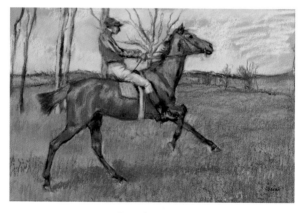

The Jockey, c. 1887.
Pastel on paper, 12⅝ x 19⅜ in. (32 x 49 cm).
Philadelphia Museum of Art.

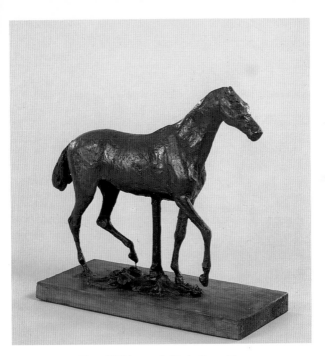

Horse Walking, probably before 1881.
Reddish wax, height: 8¼ in. (21 cm).
National Gallery of Art, Washington, D.C.

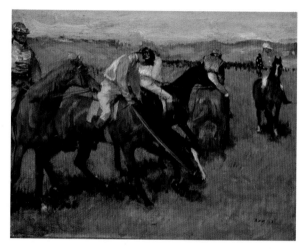

Before the Race, 1882. Oil on panel,
10½ x 13¾ in. (26.5 x 34.9 cm). Sterling and Francine Clark
Art Institute, Williamstown, Massachusetts.

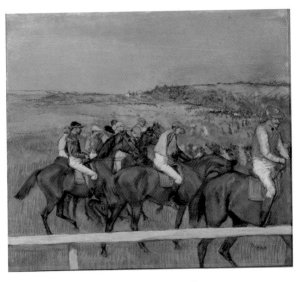

Before the Race, 1882–84.
Pastel on paper, 25¼ x 21⅝ in. (64 x 55 cm).
Museum of Art, Rhode Island School of Design, Providence.

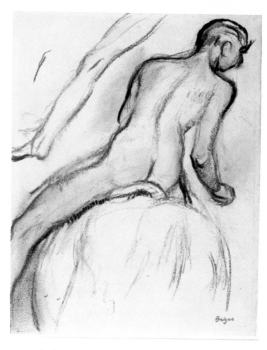

Study for a Jockey, c. 1887–90. Charcoal on paper,
12¼ x 9¾ in. (31 x 24.9 cm). Museum Boymans-
van Beuningen, Rotterdam, Netherlands.

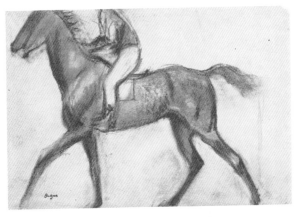

Horse and Jockey, 1887–1890. Red chalk on paper,
11⅛ x 16⅜ in. (28.3 x 41.8 cm). Museum Boymans-
van Beuningen, Rotterdam, Netherlands.

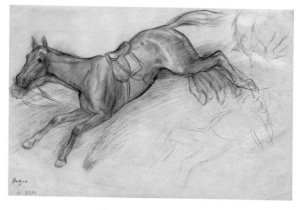

Jumping Horse, 1866.
Pencil on paper, 9⅛ x 14 in. (23.1 x 35.5 cm). Sterling and
Francis Clark Art Institute, Williamstown, Massachusetts.

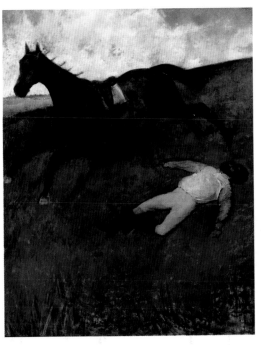

The Fallen Jockey, 1896–98.
Oil on canvas, 70¾ x 59½ in. (181 x 151 cm).
Kunstmuseum Basel, Switzerland.

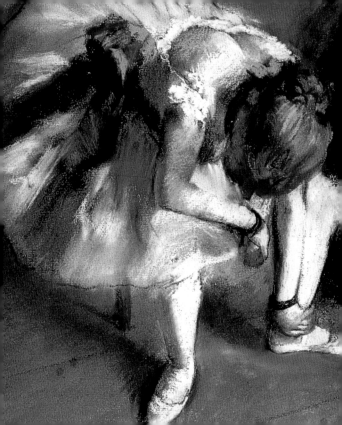

DANCERS AND MUSICIANS

Of all the novel themes that Degas discovered in the years around 1870, the world of ballet was the most enduring in his art. From his first little paintings of dance rehearsals around 1871, to the monumental pastels and paintings of dancers from the turn of the century, there is a remarkable evolution in Degas's treatment of the subject—the subject that is now most closely identified with his name and his art.

Degas's family was intensely interested in music, and we know that Degas was an avid opera-goer as a young man. In the Paris of his day, the ballet was the dance troupe of the Opera, performing the dance numbers that were interspersed in musical events, as well as independent ballets. To attain the *corps de ballet* was a glamorous destiny for young women of the lower and middle classes, for financial security might be found there among the gentlemen subscribers who frequented the *foyer de la danse*.

Although he had painted a large work, *Semiramis Building Babylon* (see page 35), which may have been inspired by Rossini's opera on the theme, and had portrayed Eugénie Fiocre as a dancer in the ballet *La Source* (page 155), it was Degas's portrait of his friend Désiré Dihau, bassoonist at the Opera, that first brought the world of modern

dance into his sights. In this portrait, called *The Orchestra of the Opera* (page 158), the stockinged legs and pink skirts of the dancers provide a joyful, peripheral contrast to the black coats of the musicians below. The painting announces the arrival of the theme that was to occupy Degas for decades.

In 1874 the writer Edmond de Goncourt paid a visit to Degas in his studio, and was shown some of the painter's recent work. He was particularly struck by a canvas—*The Rehearsal* (page 168)—that showed "the *foyer de la danse,* with the fantastic silhouette of the dancers' legs descending a little staircase seen in the midst of all these ballooning white clouds, with the rascally little *repoussoir* of a ridiculous ballet master. And there before you, caught off guard, is the graceful twisting of the movements and gestures of the little ape-girls." From the painting, Goncourt turned to the painter, who "shows you his pictures, adding to his explanation from time to time by miming a *developpement,* by imitating, with the expression of the dancers, one of their arabesques. And it really is very funny to see him, up on point, his arms rounded, mixing the aesthetic of the dance master with the aesthetic of the painter."

While Degas frequently depicted dancers on the stage, in performance, the majority of his images of ballet deal with the practice sessions and lessons that took place during the daytime hours. Degas's images of dancers at work,

whether they are executing a movement or resting between exercises, reveal his sure appreciation of the difficulty of their craft—a craft that he may have identified with his own painstaking search for artistic perfection. "Do not imagine that the hard work of the dancing lesson will be quickly finished," wrote one observer. "It must go on forever and renew itself without taking a break."

The penetrating exactness with which Degas drew and painted the rigors of the dancer's life is at odds with the statements he later made to explain his interest in the theme. To the American collector Louisine Havemeyer he claimed that he found in the dance a way to retrieve "the movements of the ancients." "People call me the painter of dancing girls," he griped to Vollard. "It has never occurred to them that my chief interest in dancers lies in rendering movement and painting pretty clothes."

Degas was less clever, perhaps, and more truthful, when he stated that "the dancer is nothing but a pretext for drawing." His most famous sculpture, the *Little Fourteen-Year-Old Dancer* (page 189), was in fact based on a series of drawings made of a young student at the Opera ballet school, drawings that satisfy the artist's desire to expand his knowledge of form, but that show, too, his sensitivity to the individual characteristics of his model. To one little dancer—probably this one—Degas even addressed a sonnet (translated by Richard Howard):

Dance, winged scamp, dance on the wooden lawns.
Love only that—let dancing be your life.
Your skinny arm assumes the attitude
And balances your flight against your weight.

Taglioni, come, Princess of Arcady!
Nymphs, Graces, come you souls of yore,
Ennoble and endow, smiling at my choice,
With form the boldfaced little neophyte.

Montmartre may give the breeding and the mind,
Roxelane the nose, and China the eyes—
But vigilant Ariel offers this recruit

The dancing feet of daylight and of dark.
Then for my pleasure let her know her worth
And keep, in the golden hall, the gutter's breed.

We know, indeed, that Degas could be quite senti-
mental about the dancers. To the sculptor Albert Bar-
tholomé, he wrote in 1886 of his sense of advancing age,
saying that "with the exception of the heart, it seems to me
that everything within me is growing old in proportion.
And even my heart has something artificial about it. The
dancers have sewn it up in a bag of pink satin, pink satin a
bit worn, like their dancing slippers."

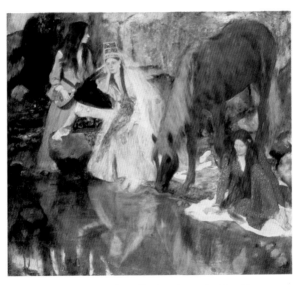

Mlle. Fiocre in the Ballet "La Source," 1867–68.
Oil on canvas, 51⅛ x 57⅛ in. (130 x 145 cm).
The Brooklyn Museum.

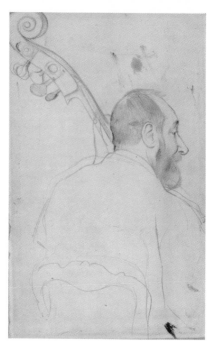

A Study of M. Gouffé, c. 1869.
Pencil on paper, 7⅜ x 4¾ in. (18.8 x 12 cm).
Mr. and Mrs. Eugene Victor Thaw, New York.

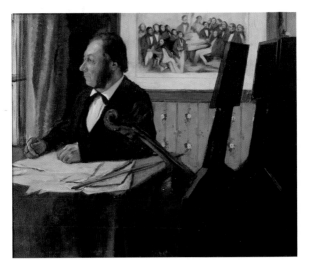

Louis-Marius Pilet, c. 1869.
Oil on canvas, 37⅝ x 24 in. (95.5 x 61 cm).
Musée d'Orsay, Paris.

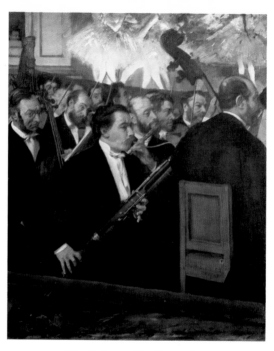

The Orchestra of the Opera, 1870.
Oil on canvas, 22¼ x 18¼ in. (56.5 x 46.2 cm).
Musée d'Orsay, Paris.

Orchestra Musicians, 1870–71, reworked c. 1874–76.
Oil on canvas, 27⅛ x 19¼ in. (69 x 49 cm).
Städtische Galerie im Städelschen Kunstinstitut, Frankfurt.

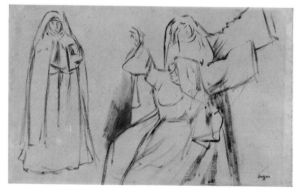

Three Nuns, study for "The Ballet from Robert le Diable," c. 1871.
Brush and ink on paper, 11 x 17¾ in. (28 x 45 cm).
The Victoria and Albert Museum, London.

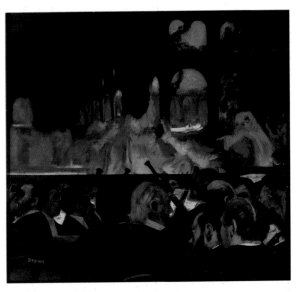

The Ballet from Robert le Diable, c. 1876.
Oil on canvas, 29¾ x 32 in. (76.6 x 81.3 cm).
The Victoria and Albert Museum, London.

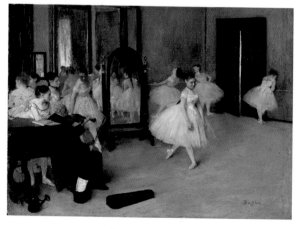

Dance Class, 1871.
Oil on panel, 7¾ x 10⅝ in. (19.7 x 27 cm).
The Metropolitan Museum of Art, New York.

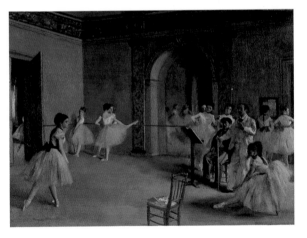

Dance Class at the Opera, 1872.
Oil on canvas, 12⅝ x 18⅛ in. (32 x 46 cm).
Musée d'Orsay, Paris.

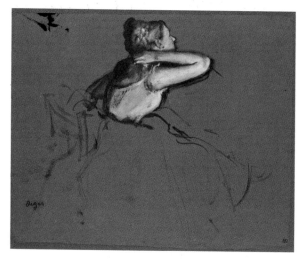

Seated Dancer in Profile, 1873.
Essence on blue paper, 9 x 11½ in. (23 x 29.2 cm).

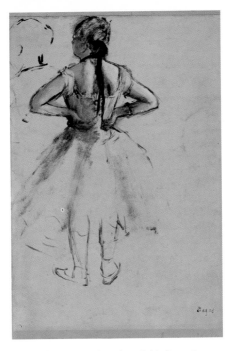

Standing Dancer Seen from Behind, c. 1873.
Essence on pink paper, 15½ x 11 in. (39.4 x 27.8 cm).
Cabinet des Dessins, Musée du Louvre (Orsay), Paris.

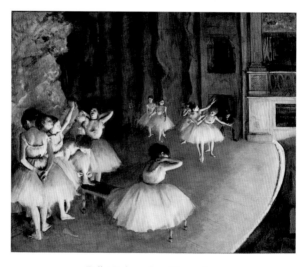

Ballet Rehearsal on Stage, 1874.
Oil on canvas, 25⅝ x 31⅞ in. (65 x 81 cm).
Musée d'Orsay, Paris.

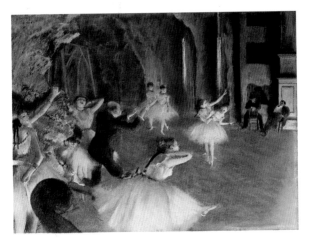

The Rehearsal on the Stage, c. 1874. Pastel over ink drawing on
paper, mounted on canvas, 21 x 28½ in. (53.3 x 72.3 cm).
The Metropolitan Museum of Art, New York.

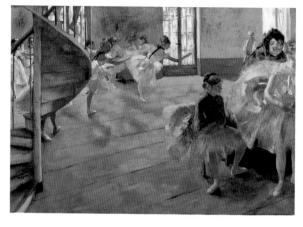

The Rehearsal, 1874.
Oil on canvas, 23 x 33 in. (58.4 x 83.8 cm).
The Burrell Collection, Glasgow.

Jules Perrot, 1875.
Essence on tan paper, 19 x 11½ in. (48.1 x 30.3 cm).
Philadelphia Museum of Art.

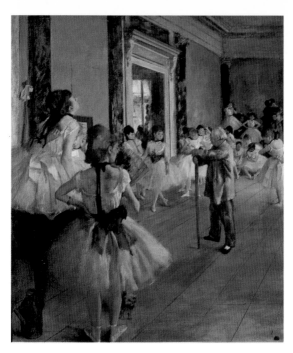

The Dance Class, begun 1873, completed c. 1876.
Oil on canvas, 33½ x 29½ in. (85 x 75 cm).
Musée d'Orsay, Paris.

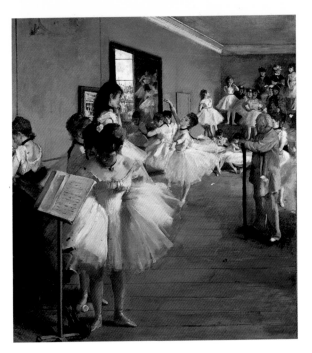

The Dance Class, 1874.
Oil on canvas, 33 x 31¾ in. (83.8 x 79.4 cm).
The Metropolitan Museum of Art, New York.

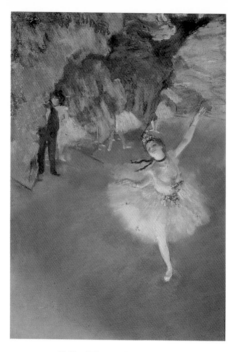

Ballet (The Star), 1876–77.
Pastel over monotype, 22⅞ x 16½ in. (58 x 42 cm).
Musée d'Orsay, Paris.

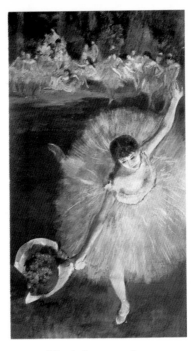

The Arabesque, c. 1877.
Essence and pastel on canvas, 26⅜ x 15 in. (67 x 38 cm).
Musée d'Orsay, Paris.

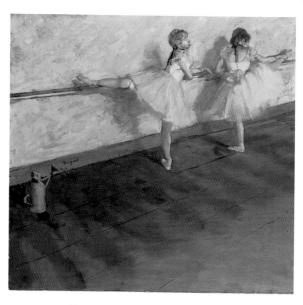

Dancers Practicing at the Bar, 1876–77.
Essence on canvas, 29¾ x 32 in. (75.6 x 81.3 cm).
The Metropolitan Museum of Art, New York.

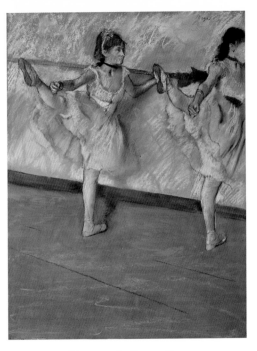

Dancers at the Bar, c. 1877.
Pastel on paper, 26 x 20⅛ in. (66 x 51 cm).
Private collection.

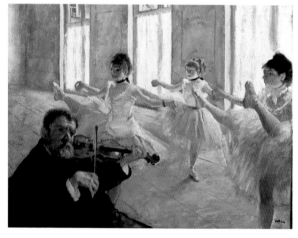

The Rehearsal, c. 1878–79.
Oil on canvas, 18¾ x 24 in. (47.6 x 61 cm).
The Frick Collection, New York.

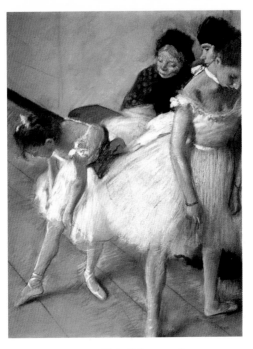

Dancers at Their Toilette, c. 1879.
Pastel on paper, 25 x 19 in. (63.4 x 48.2 cm).
Denver Art Museum.

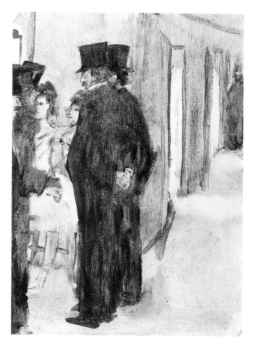

Pauline and Virginie Chatting with Their Admirers, c. 1877.
Monotype in black ink on paper, 8⁷⁄₁₆ x 6⁵⁄₁₆ in. (21.5 x 16 cm).
Harvard University Art Museums,
Fogg Art Museum, Cambridge, Massachusetts.

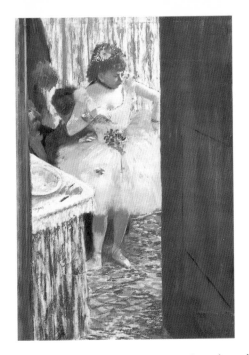

Dancer in Her Dressing Room, c. 1877. Gouache and pastel on paper, 23⅝ x 15¾ in. (60 x 40 cm). Oskar Reinhart Collection, "Am Römerholz," Winterthur, Switzerland.

179

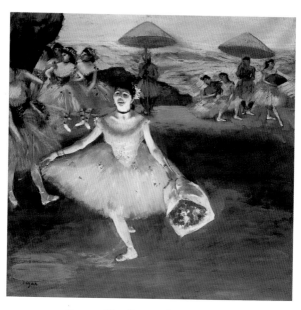

Dancer with a Bouquet Bowing, c. 1877.
Pastel and gouache on paper, 28⅜ x 30⅝ in. (72 x 77.5 cm).
Musée d'Orsay, Paris.

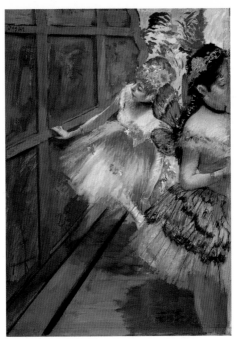

Dancers in the Wings, c. 1878. Pastel and distemper on paper,
26¼ x 18⅝ in. (66.7 x 47.3 cm).
Norton Simon Art Foundation, Pasadena, California.

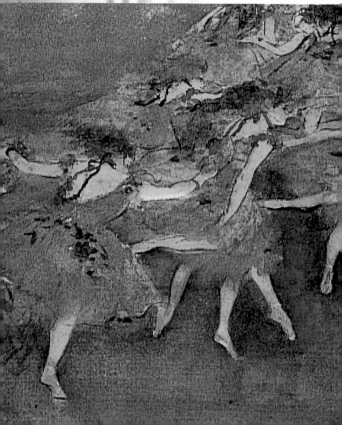

A Fan: La Farandole, c. 1879.
Gouache on silk, with silver and gold,
12 x 24 in. (30.7 x 61 cm). Private collection.

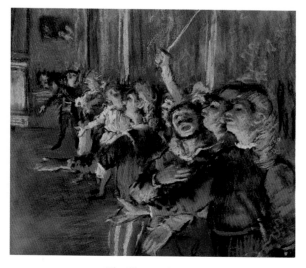

The Chorus, 1876–77.
Pastel over monotype on paper, 10⅝ x 12¼ in. (27 x 31 cm).
Musée d'Orsay, Paris.

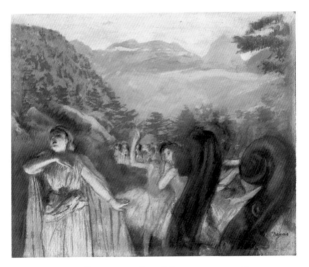

Aria after the Ballet, c. 1879. Pastel (over monotype?) on paper,
23½ x 29½ in. (59.7 x 75 cm). Dallas Museum of Art;
Wendy and Emery Reves Collection.

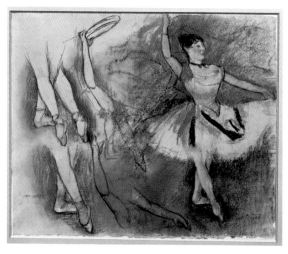

Sheet of Studies: Dancer with a Tambourine, c. 1882.
Pastel and black chalk on paper, 18⅛ x 22⅞ in. (46 x 58 cm).
Musée d'Orsay, Paris.

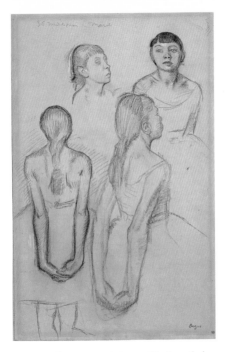

Four Studies of a Dancer, 1878–79. Chalk and charcoal
on paper, 19¼ x 12⅝ in. (48.9 x 32.1 cm).
Cabinet des Dessins, Musée du Louvre (Orsay), Paris.

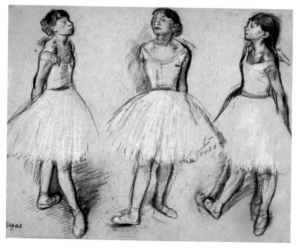

Three Studies of a Dancer in Fourth Position, c. 1879–80.
Charcoal and pastel on buff paper, 18⅞ x 24¼ in.
(48 x 61.6 cm). The Art Institute of Chicago.

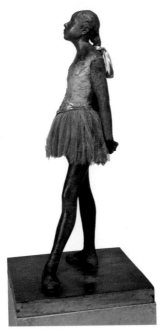

The Little Fourteen-Year-Old Dancer, 1879–81.
Wax, cotton skirt and bodice, hair wig covered with wax,
hair ribbon, on wooden base; height: 37½ in. (95.2 cm).
Mr. and Mrs. Paul Mellon.

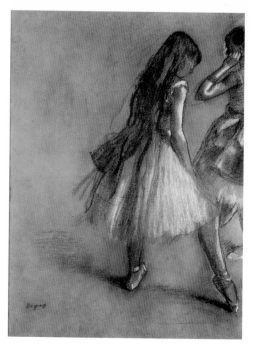

Two Dancers, c. 1878–80.
Pastel and charcoal on paper, 8¼ x 12¾ in. (46.4 x 32.4 cm).
Private collection.

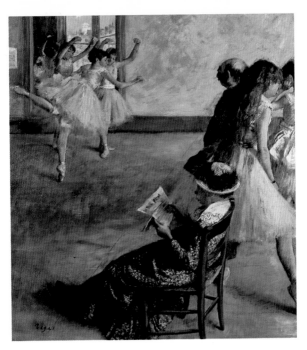

The Dance Class, 1881.
Oil on canvas, 32⅛ x 30⅛ in. (81.6 x 76.5 cm).
Philadelphia Museum of Art.

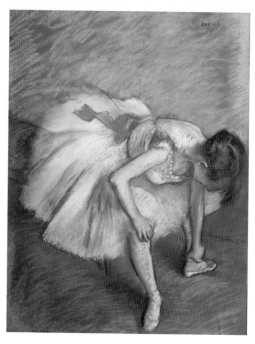

Seated Dancer, c. 1881.
Pastel on paper, 24⅜ x 19¼ in. (62 x 49 cm).
Musée d'Orsay, Paris.

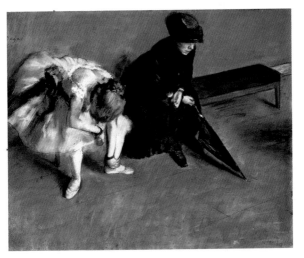

Waiting, c. 1882. Pastel on paper, 18½ x 23⅝ in. (47 x 60 cm).
Jointly owned by the Norton Simon Art Foundation,
Pasadena, California, and The J. Paul Getty Museum,
Malibu, California.

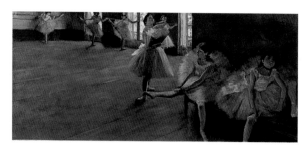

The Dancing Lesson, c. 1880. Oil on canvas,
15½ x 34¾ in. (39.4 x 88.4 cm). Sterling and Francine Clark
Art Institute, Williamstown, Massachusetts.

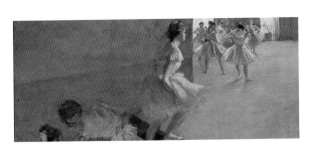

Dancers Climbing the Stairs, c. 1888.
Oil on canvas, 15⅜ x 35⅜ in. (39 x 90 cm).
Musée d'Orsay, Paris.

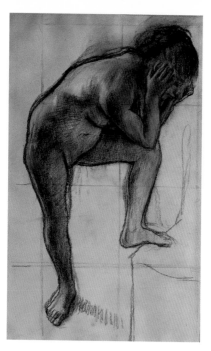

Nude Dancer with Her Head in Her Hands, c. 1882–85.
Pastel and charcoal on blue paper, 19½ x 12⅛ in.
(49.5 x 30.7 cm). Musée d'Orsay, Paris.

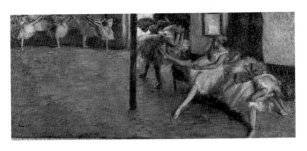

Ballet Rehearsal, c. 1890.
Oil on canvas, 14⅛ x 34½ in. (38 x 90 cm).
Yale University Art Gallery, New Haven, Connecticut.

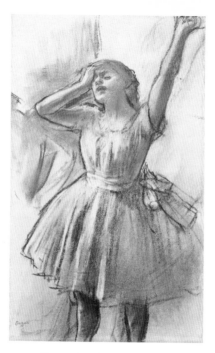

Dancer Stretching, c. 1882–85.
Pastel on gray paper, 18⅜ x 11¾ in. (46.7 x 29.7 cm).
Kimbell Art Museum, Fort Worth.

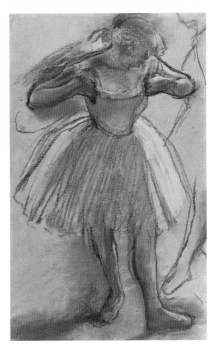

Standing Dancer, 1885–90.
Pastel on gray paper, 18⅝ x 11¾ in. (47.2 x 29.8 cm).
Museum of Art, Rhode Island School of Design, Providence.

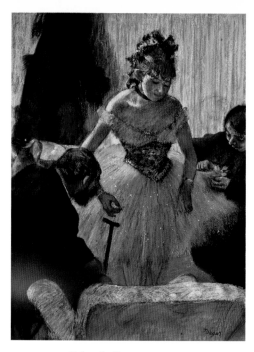

Before the Entrance, c. 1880.
Pastel on paper, 23¼ x 17¾ in. (58 x 44 cm).
Private collection.

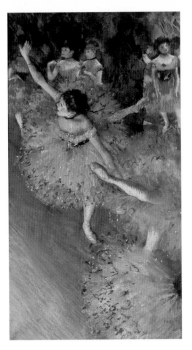

The Green Dancer (Dancers on the Stage), c. 1880.
Pastel and gouache on paper, 26 x 14¼ in. (66 x 36 cm).
Collecion Thyssen-Bornemisza, Madrid.

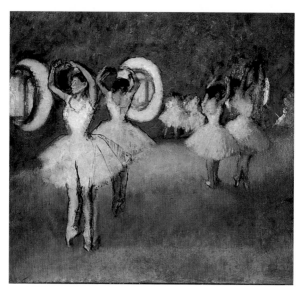

Dance Rehearsal in the Foyer of the Opera, c. 1890.
Oil on canvas, 34⅞ x 37¾ in. (88.6 x 95.9 cm).
Norton Simon Art Foundation, Pasadena, California.

202

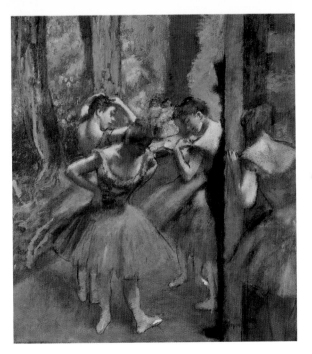

Dancers, Pink and Green, c. 1890.
Oil on canvas, 32⅜ x 29¾ in. (82.2 x 75.6 cm).
The Metropolitan Museum of Art, New York.

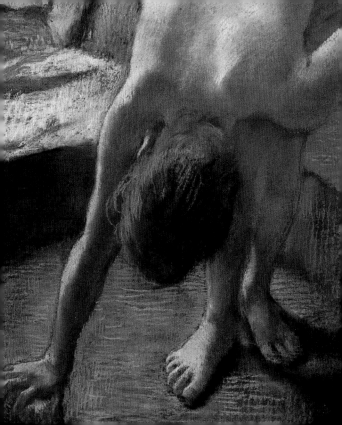

NUDES

To draw and paint the human figure, and especially the nude, was the summit of academic achievement in the official art circles of Degas's day. Degas, like his fellow students at the Ecole des Beaux-Arts, and like the independent artists with whom he came into contact in Italy, revered the nude figure, copying nudes from classical and Renaissance sculpture, from paintings and engravings, and finally attending "life classes," where a nude model was provided for the student's observation and study.

Drawings that Degas made for his history paintings of the 1860s—such as *Young Spartans* and *Scene of War in the Middle Ages* (see pages 37 and 41)—showed his early mastery of the nude figure in motion or at rest. He would continue to paint and draw the nude for the rest of his career, but after the 1860s, his nudes were resolutely modern. "See how different the times are for us," he said to a friend, "two centuries ago I would have been painting *Susannah Bathing,* now I just paint *Woman in a Tub.*"

In the 1870s, Degas pursued this modern nude in a series of monotype prints of women in interiors. Some of these prints were left in black and white, and others were enhanced with pastel to more closely resemble small paintings. Some clearly represent the bedrooms and reception rooms of brothels (*The Name Day of the Madam,* page 211,

is a good example), but others are less explicit, and might represent any woman bathing, drying herself, or reading by an oil lamp after her bath. Few, if any, of these prints seem to have been exhibited publicly in Degas's lifetime; some of the more daring of them appear to have been destroyed by his family after the artist's death.

The poses that Degas evolved in the "domestic" monotypes may have suggested to him a range of expressive possibilities in the nude, for in the mid-1880s he produced a number of large and beautifully finished pastels on the theme of bathers. Ten of these were exhibited together in the last Impressionist exhibition, in 1886, under the general description "Suite of female nudes bathing, washing, drying themselves, wiping themselves, combing their hair or having their hair combed." In the series, none of the women looks directly at the viewer: each is seen from close up, but seems concerned only with her own task. In spite of—or because of—their lack of erotic subtext, the nudes caused a furor in the artistic press. Some critics thought them exceptionally fine, while others were scandalized by their frankness. Describing *Woman Bathing in a Shallow Tub* (page 222), one writer remarked that Degas had "hidden nothing of her froglike appearance, . . . the stunning apparition of paunches, knees, and feet unexpectedly foreshortened," while a more favorable reviewer saw in the same pastel "the loveliness and power of a Gothic statue."

Even in Degas's lifetime, the uncompromising realism of the 1880s nudes left him open to charges of artistic cruelty. "Women can never forgive me," he said to one writer. "They hate me, they can feel that I am disarming them. I show them without their coquetry, in the state of animals cleaning themselves." In our century, as in Degas's time, authors have disagreed about Degas's alleged misogyny, some seeing in his disarmingly frank treatment of women the mark of respect, others believing his unflattering depictions to be the result of hatred or fear of women.

Whatever our point of view, the female nude gave Degas a subject that could stir his audience and that could endlessly inspire him to new compositional and formal inventions. As he pursued his study of the nude, Degas turned to sculpture, building figures in wax and modeling clay, destroying a figure and re-forming it if it disappointed his strict self-imposed standards. One of his great successes was a sculpture called *The Tub* (page 227), a work of the late 1880s. A nude woman, sculpted in wax, clings to the side of a shallow basin with her left hand as she washes her left foot with the other hand. The basin, of lead, is filled with "water" sculpted in white plaster, while the whole rests on a crumpled "sheet" of plaster-soaked fabric. Seen from above, the figure is inscribed within a circle within a square—a modern version of a Della Robbia roundel.

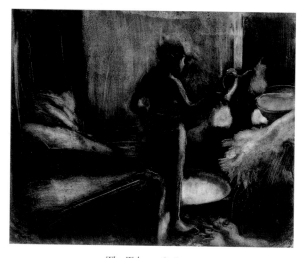

The Tub, c. 1876–77.
Monotype in black ink on paper, 16½ x 21¾ in.
(42 x 54.1 cm). Bibliothèque d'Art et d'Archéologie,
Université de Paris (Fondation Jacques Doucet).

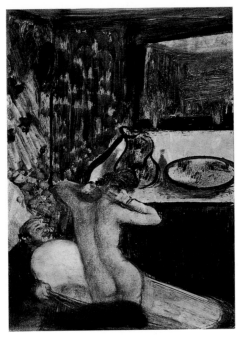

Admiration, c. 1877–80.
Monotype in black ink with pastel on paper, 8½ x 6⅜ in.
(21.5 x 16.1 cm). Bibliothèque d'Art et d'Archéologie,
Université de Paris (Fondation Jacques Doucet).

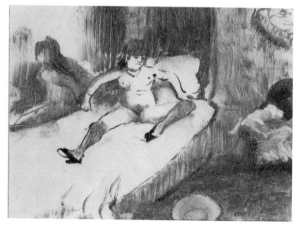

On the Bed, 1878–79.
Monotype in black ink on paper, 4¾ x 6½ in.
(12.1 x 16.4 cm). Musée Picasso, Paris.

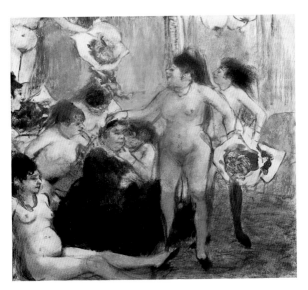

The Name Day of the Madam, 1876–77.
Pastel over monotype on paper, 10½ x 11⅝ in.
(26.6 x 29.6 cm). Musée Picasso, Paris.

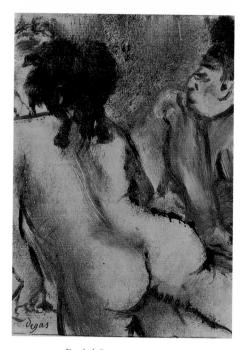

Brothel Scene, c. 1878–79.
Monotype in black ink on paper, 6¼ x 4⅝ in.
(16.1 x 11.8 cm). Bibliothèque d'Art et d'Archéologie,
Université de Paris (Fondation Jacques Doucet).

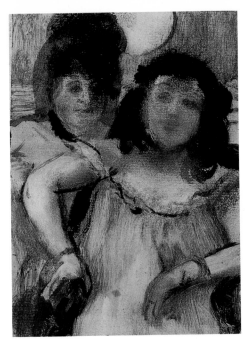

Two Women, c. 1878–79.
Monotype in black ink with pastel on paper, 6⅜ x 4¾ in.
(16.3 x 11.9 cm). Bibliothèque d'Art et d'Archéologie,
Université de Paris (Fondation Jacques Doucet). 213

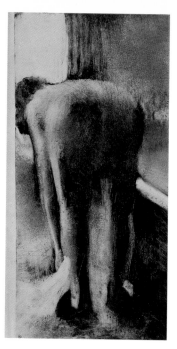

Nude Woman Wiping Her Feet, c. 1879–83. Monotype in
black ink in paper, image 17¾ x 9⅜ in. (45.1 x 23.9 cm).
Cabinet des Dessins, Musée du Louvre (Orsay), Paris.

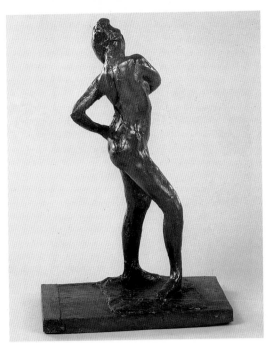

Dancer Fastening the String of Her Tights, c. 1885/90 (?).
Yellow-brown plastilene, height: 16¾ in. (42.6 cm).
National Gallery of Art, Washington, D.C.

215

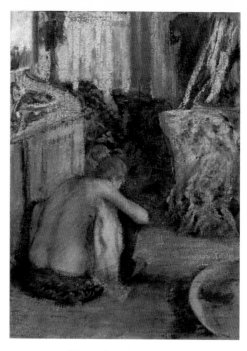

Woman Squatting, c. 1879.
Pastel on monotype, 7⅛ x 5½ in. (18 x 14 cm).
Musée d'Orsay, Paris.

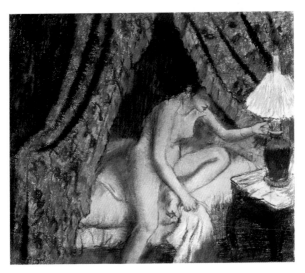

Retiring, c. 1883.
Pastel on paper, 14⅜ x 16⅞ in. (36.4 x 43 cm).
The Art Institute of Chicago.

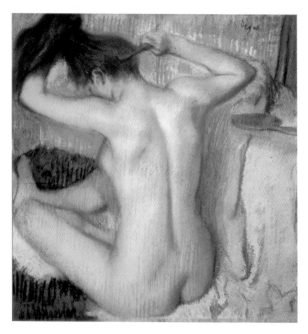

Nude Woman Combing Her Hair, c. 1884–86.
Pastel on paper, 21⅝ x 20½ in. (55 x 52 cm).
The Hermitage Museum, St. Petersburg, Russia.

Torso of a Woman, c. 1885?
Monotype in brown ink on paper, 19¾ x 15½ in.
(50 x 39.3 cm). Bibliothèque Nationale, Paris.

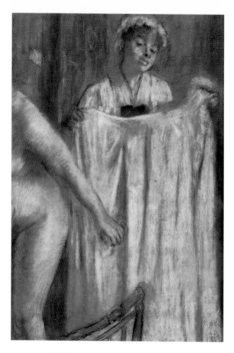

The Toilette after the Bath, c. 1885.
Pastel on paper, 31⅞ x 22 in. (81 x 56 cm).
Ny Carlsberg Glyptothek, Copenhagen, Denmark.

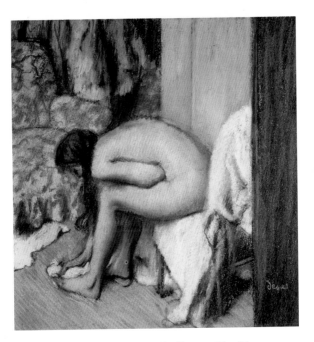

Nude Woman Drying Her Feet, c. 1885–86.
Pastel on paper, 21⅜ x 20⅝ in. (54.3 x 52.4 cm).
Musée d'Orsay, Paris.

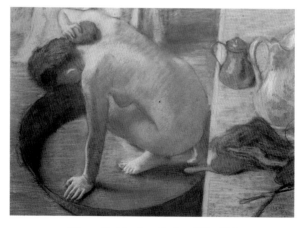

Woman Bathing in a Shallow Tub, 1886.
Pastel on paper, 23⅞ x 32⅝ in. (60 x 83 cm).
Musée d'Orsay, Paris.

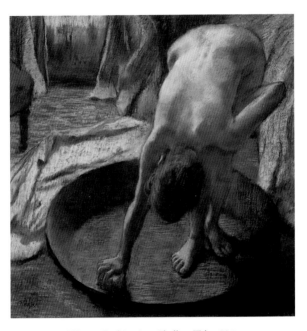

Woman Bathing in a Shallow Tub, 1886.
Pastel on paper, 27½ x 27½ in. (70 x 70 cm).
Hill-Stead Museum, Farmington, Connecticut.

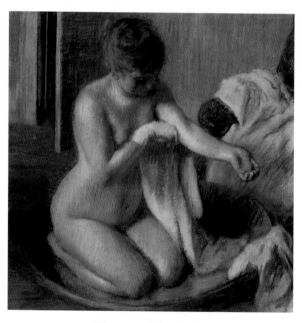

Woman in a Tub, 1884–86.
Pastel on paper, 27½ x 27½ in. (68 x 68 cm).
The Tate Gallery, London.

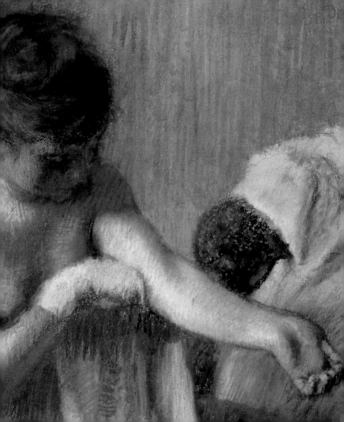

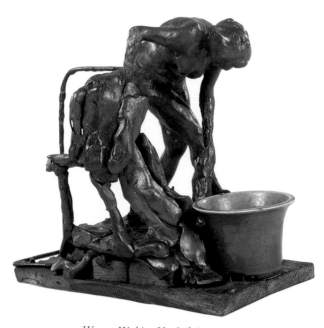

Woman Washing Her Left Leg, c. 1890.
Yellow, red and olive green wax,
small green ceramic pot, height: 7⅞ in. (20 cm).
National Gallery of Art, Washington, D.C.

The Tub, 1888–89.
Wax figure in lead basin covered with plaster, on a base of
plaster-soaked cloth and wood, diameter: 18½ in. (47 cm).
National Gallery of Art, Washington, D.C.

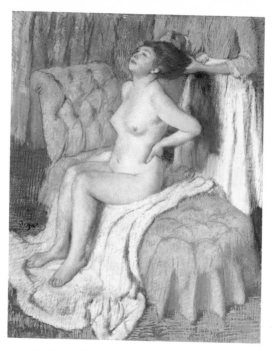

Nude Woman Having Her Hair Combed, c. 1886–88.
Pastel on paper, 29⅛ x 23⅞ in. (74 x 60.6 cm).
The Metropolitan Museum of Art, New York.

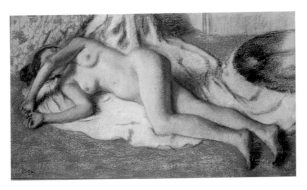

Reclining Bather, 1886.
Pastel on paper, 18⅞ x 34¼ in. (48 x 87 cm).
Musée d'Orsay, Paris.

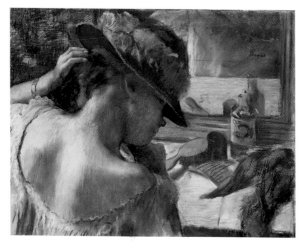

Woman before a Mirror, c. 1885–86.
Pastel on paper, 19¼ x 25¼ in. (49 x 64 cm).
Hamburger Kunsthalle, Germany.

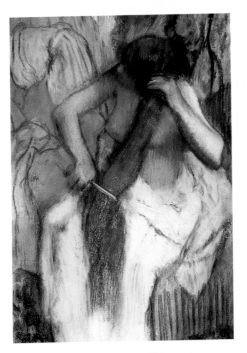

Young Woman Combing Her Hair, c. 1890–92.
Pastel on paper, 32½ x 23⅜ in. (82 x 57 cm).
Musée d'Orsay, Paris.

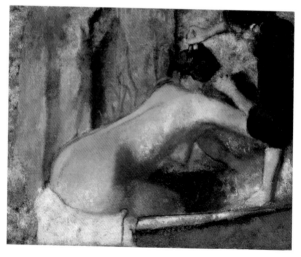

Woman at Her Bath, c. 1895.
Oil on canvas, 28 x 35⅜ in. (71 x 89 cm).
The Art Gallery of Ontario, Toronto.

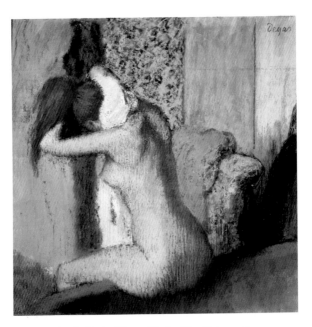

After the Bath, Woman Drying Her Neck, c. 1895.
Pastel on paper, 24½ x 25⅝ in. (62.2 x 65 cm).
Musée d'Orsay, Paris.

LATE WORK

By the 1890s Degas was an acknowledged master, commanding high prices for his works, when he sold them, and increasingly the focus of critical recognition. After the final Impressionist exhibition, in 1886, Degas did not regularly show his paintings and pastels, although dealers to whom he sold them could organize small presentations of his art. He began to travel extensively, and to collect works by great artists whom he admired—not only his colleagues in the Impressionist movement, but also the much-revered Ingres and Delacroix, and the young Paul Gauguin.

In 1890, Degas took a trip to Burgundy with his friend Bartholomé, traveling in a horse-drawn buggy. At the home of an artist friend, he made a remarkable series of nearly abstract monotypes in colored ink, each suggesting a landscape observed or imagined by the traveler. Later, in Paris, he made more of these, and heightened them with layers of pastel, sometimes delicate, sometimes thick and crusty. In the fall of 1892, Degas showed more than twenty of these landscapes at the gallery of his dealer Paul Durand-Ruel. It was the last exhibition of his work that he was to organize—and the only solo exhibition of his career.

The foray into landscape (he would return briefly to

painting landscapes in the late 1890s) was also the artist's last foray into new subject matter. Throughout the 1890s, and into the first decade of the twentieth century, Degas returned to familiar subjects. Whether treating dancers, bathers, the races, or making portraits, Degas discovered new and amazing formal solutions to problems that he had first posed a generation earlier.

He took up photography with a manic passion around 1895, creating some of the most original experiments of the decade. In his more accustomed media, the late dancers took on a new brilliance of color and boldness of surface treatment. Outlines were strengthened, whether in oil paintings or in the charcoal and pastel concoctions that became the artist's preference. Both dancers and bathers were arranged, on occasion, into elaborate, sinuous compositions, where figures are juxtaposed in a shallow space, or strewn as if by chance across a receding ground. Although we know that Degas hired models to pose for him during these years, we also know that many of his works are based on other works, as Degas made counter-impressions and tracings of his own charcoal drawings and pastels.

It would be simple to attribute much of Degas's technical boldness and artistic self-absorption to the problems of sight, present since the 1870s, that began gravely to affect him around 1900, and to the increasing seclusion

he entered after the turn of the century. But the apparent boldness and simplicity of Degas's color in a slightly earlier work such as *The Coiffure* (page 265) is deceiving: the forms are strongly outlined, but also sensitively shaded; the colors are intense, but also subtly varied. Although he complained of loneliness, Degas saw and corresponded with close friends, such as the painter Suzanne Valadon. To the son of one of his oldest friends, he wrote in 1907 that he was "still here working. Here I am back at drawing and pastel. I should like to succeed in finishing my articles. At all cost it must be done. Journeys do not tempt me any more."

Landscape (Burgundy Landscape), 1890.
Monotype in oil colors on paper, 11⅞ x 15¾ in. (30 x 40 cm).
Cabinet des Dessins, Musée du Louvre (Orsay), Paris.

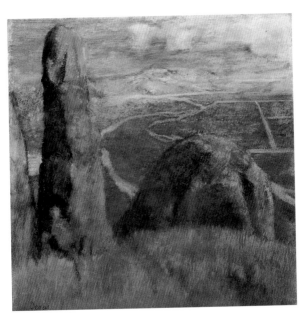

Landscape, c. 1892.
Pastel on paper, 19¼ x 19⅜ in. (48.9 x 49.2 cm).
The Museum of Fine Arts, Houston.

239

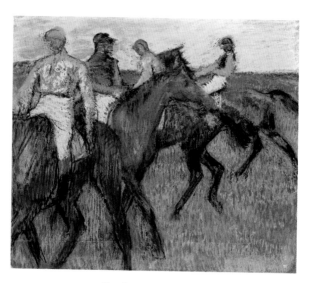

Racehorses, 1895–1900.
Pastel on paper, 21¼ x 24¾ in. (54 x 63 cm).
National Gallery of Canada, Ottawa.

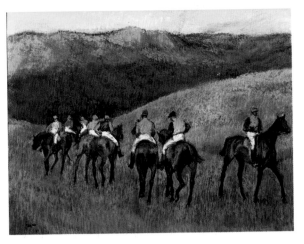

Racehorses in a Landscape, 1894.
Pastel on paper, 19¼ x 23¾ in. (48.9 x 62.8 cm).
Collecion Thyssen-Bornemisza, Madrid.

At Saint-Valéry-sur-Somme, 1896–98.
Oil on canvas, 26⅝ x 31⅞ in. (67.5 x 81 cm).
Ny Carlsberg Glyptothek, Copenhagen, Denmark.

Houses at the Foot of a Cliff, 1896–98.
Oil on canvas, 36¼ x 28¾ in. (92 x 73 cm).
Columbus Museum of Art, Ohio.

Renoir and Mallarmé, 1895. Gelatin silver photographic print,
15¼ x 11½ in. (38.9 x 29.2 cm).
Bibliothèque Littéraire Jacques Doucet, Paris.

Mallarmé and Paule Gobillard, 1896.
Gelatin silver photographic print, 11½ x 14½ in.
(29.2 x 37 cm). Musée d'Orsay, Paris.

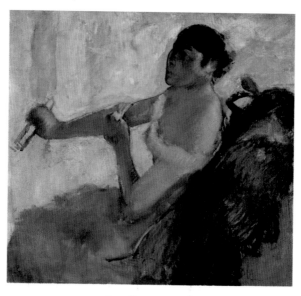

Rose Caron, c. 1892.
Oil on canvas, 30 x 32½ in. (76.2 x 86.2 cm).
Albright-Knox Art Gallery, Buffalo.

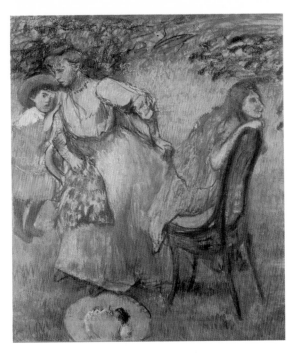

Mme. Alexis Rouart and Her Children, c. 1905.
Pastel on paper, 63 x 55½ in. (160 x 141 cm).
Musée du Petit Palais, Paris.

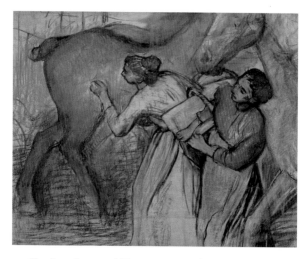

Two Laundresses and Horses, c. 1905. Charcoal and pastel
on tracing paper, 33⅛ x 42⅛ in. (84 x 107 cm).
Musée Cantonal des Beaux-Arts, Lausanne, Switzerland.

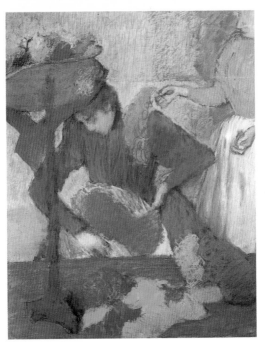

At the Milliner's, c. 1905–1910.
Pastel on paper, 35¾ x 29½ in. (91 x 75 cm).
Musée d'Orsay, Paris.

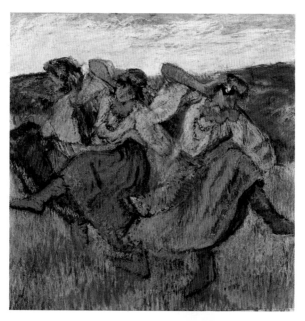

Russian Dancers, 1899. Pastel on paper,
24½ x 24¾ in. (62.2 x 62.9 cm). The Museum of Fine Arts,
Houston; The John A. and Audrey Jones Beck Collection.

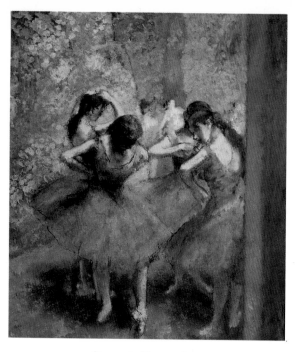

Dancers in Blue, c. 1893.
Oil on canvas, 33⁷⁄₁₆ x 29¾ in. (85 x 75.5 cm).
Musée d'Orsay, Paris.

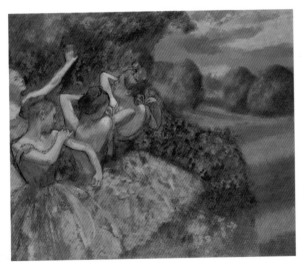

Four Dancers, c. 1896–98.
Oil on canvas, 59 x 71 in. (150 x 180 cm).
National Gallery of Art, Washington, D.C.

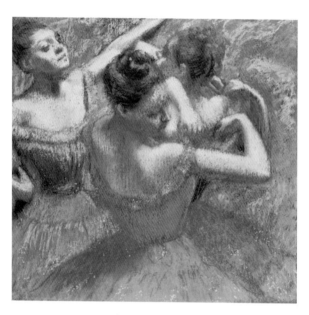

The Dancers, c. 1899.
Pastel on paper, 24½ x 25½ in. (62.2 x 64.8 cm).
The Toledo Museum of Art, Ohio.

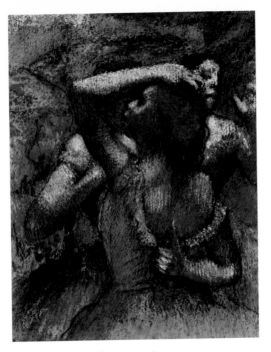

Dancers, c. 1899.
Pastel on paper, 22⅛ x 18⅛ in. (56 x 46 cm).
The Art Museum, Princeton University, New Jersey.

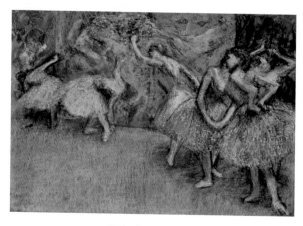

Ballet Scene, c. 1900.
Pastel on paper, 30¼ x 43¾ in. (76.8 x 111.2 cm).
National Gallery of Art, Washington, D.C.

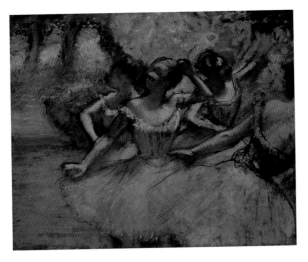

Four Dancers on Stage, c. 1900.
Oil on canvas, 28¾ x 36⅛ in. (73 x 92 cm).
Museu de Art de São Paulo Assis Chateaubriand, Brazil.

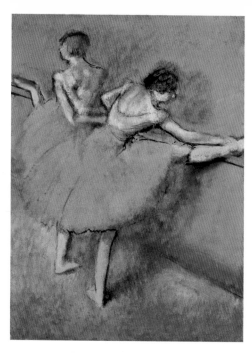

Dancers at the Bar, c. 1900.
Oil on canvas, 51 x 38 in. (130 x 96.5 cm).
The Phillips Collection, Washington, D.C.

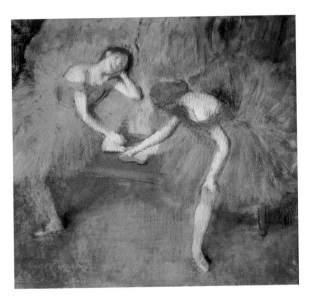

Two Dancers Resting, c. 1900.
Pastel on paper, 36¼ x 40⅝ in. (92 x 103 cm).
Musée d'Orsay, Paris.

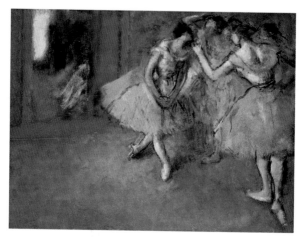

Group of Dancers, c. 1900.
Oil on canvas, 18⅛ x 24 in. (46 x 61 cm).
National Gallery of Scotland, Edinburgh.

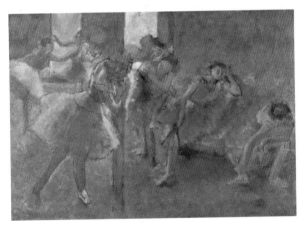

Dancers in the Rehearsal Room, c. 1900–1910.
Oil on canvas, 27¾ x 39⅝ in. (70.5 x 100.5 cm).
Von der Heydt Museum, Wuppertal, Germany.

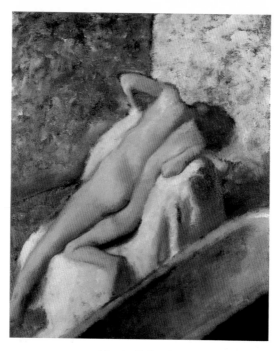

After the Bath, 1896.
Oil on canvas, 45⅝ x 38¼ in. (116 x 97 cm).
Private collection, Paris.

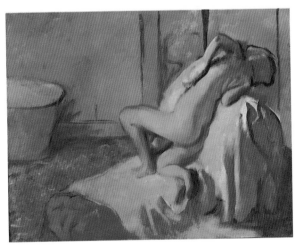

After the Bath, c. 1896.
Oil on canvas, 35 x 45¾ in. (89 x 116 cm).
Philadelphia Museum of Art.

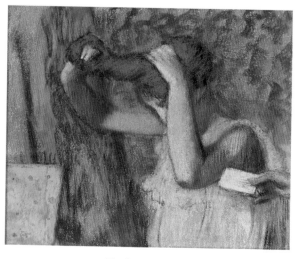

The Letter, 1890–95.
Pastel on paper, 19½ x 23⅛ in. (49.8 x 58 cm).
Private collection.

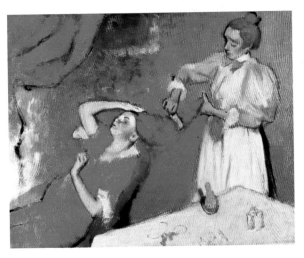

The Coiffure, c. 1896.
Oil on canvas, 48⅞ x 59 in. (124 x 150 cm).
National Gallery, London.

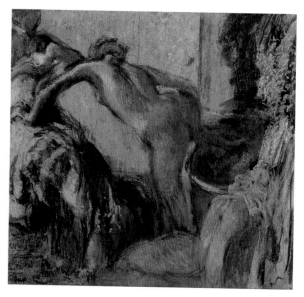

After the Bath, 1895–1900.
Pastel on paper, 30 x 32⅝ in. (76.2 x 82.8 cm).
The Phillips Collection, Washington, D.C.

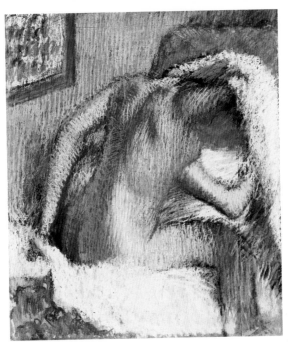

Woman Drying Her Hair, c. 1900.
Pastel on paper, 27⅝ x 28¼ in. (70.3 x 71.8 cm).
Norton Simon Museum of Art, Pasadena, California.

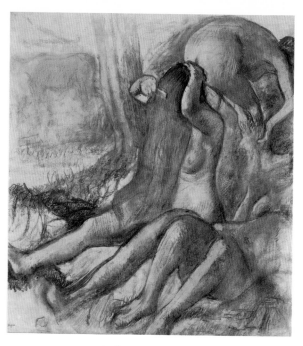

Bathers, c. 1896–1900.
Pastel and charcoal on paper, 42⅞ x 43¾ in.
(108.9 x 111.1 cm). Dallas Museum of Art.

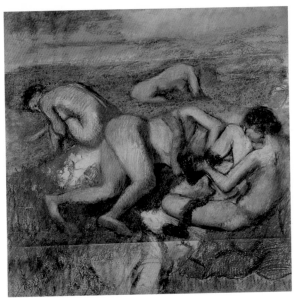

Bathers, c. 1896–1900.
Pastel on paper, 41⅛ x 42⅝ in. (104.6 x 108.3 cm).
The Art Institute of Chicago.

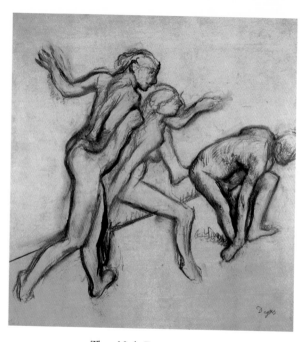

Three Nude Dancers, c. 1900.
Charcoal on paper, 35 x 34⅝ in. (89 x 88 cm).
Cabinet des Dessins, Musée du Louvre (Orsay), Paris.

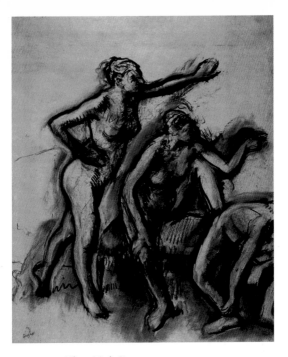

Three Nude Dancers, c. 1900–1910.
Charcoal on paper, 30⅜ x 24⅞ in. (77.2 x 63.2 cm).
The Arkansas Arts Center, Little Rock.

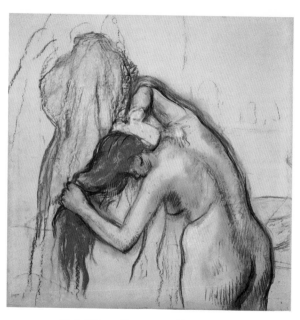

Nude Woman Drying Herself, 1900–1905.
Charcoal and pastel on paper, 31 x 32 in. (78.7 x 83.8 cm).
The Museum of Fine Arts, Houston.

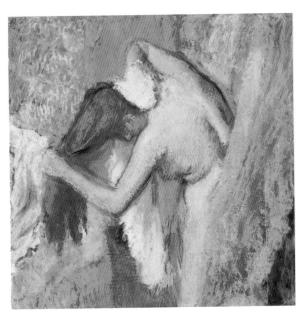

Woman at Her Toilette, 1900–1905.
Pastel on paper, 39⅜ x 28⅛ in. (74.6 x 71.3 cm).
The Art Institute of Chicago.

1834 July 19—Hilaire-Germain-Edgar Degas is born in Paris to Auguste De Gas, originally from Naples, and his wife, the former Célestine Musson of New Orleans.

1845 Enters the prestigious Lycée Louis-le-Grand, where he meets lifelong friends Henri Rouart and Paul Valpinçon.

1847 Degas's mother dies.

1853 Passes his *baccalauréat,* briefly studies law, and registers as a copyist at the Louvre and Bibliothèque Nationale.

1855 Enrolls at the Ecole des Beaux-Arts under the painter Louis Lamothe. Briefly meets the painter J.A.D. Ingres, whom he admires greatly.

1856–59 Travels to Italy, where he visits family in Naples and Florence. During his three-year stay, executes many copies after the masters, draws from live models at the French Academy in Rome, and makes many portrait studies.

1860s Continues to develop ideas for historical compositions.

1865	Exhibits *Scene of War in the Middle Ages* (page 41) at the Salon. Meets Edouard Manet around this time.
1866	Exhibits *The Wounded Jockey* at the Salon.
1870	During the Franco-Prussian war, serves with the National Guard in defending Paris; exposure to bad weather is thought to have damaged his eyes.
1870s	Develops the themes from modern life that he began to explore in the last years of the 1860s: portraits, horses and jockeys, opera and ballet, laundresses.
1872–73	Travels with his brother René to New Orleans to visit family members; paints them and scenes from their life in America, including *Portraits in an Office, New Orleans* (page 95).
1874	Degas's father dies in Italy, leaving his family business in disarray. From this date on, Degas will need to sell work to make a living and to repay his family's debts. First Impressionist exhibition opens in April; Degas sends ten works.
1876	Exhibits twenty-four works at second Impressionist exhibition.

1877	Sends twenty-five works to third Impressionist exhibition, including *Portraits in an Office,* which is later the first of his works to be acquired by a museum.
1879	Fourth Impressionist exhibition; Degas exhibits twenty pictures and five painted fans.
1880	At the opening of the fifth Impressionist exhibition, Degas's section is still incomplete; he sends in a number of works late.
1880s	Begins to travel extensively, in France and throughout the Continent.
1881	His *Little Fourteen-Year-Old Dancer* (page 189) is both admired and scorned at the sixth Impressionist exhibition.
1882	Refuses to exhibit at the seventh Impressionist exhibition.
1886	At eighth and final Impressionist exhibition shows a suite of nudes "bathing, washing, drying themselves, wiping themselves, combing their hair or having their hair combed."
1890s	Continues to build his collection of work by old masters (El Greco), nineteenth-century French masters (Ingres, Delacroix), his contemporaries (Manet, Cézanne, Pissarro, but not Monet), and younger artists (Gauguin).

Frequently travels to spas in France and Switzerland for health cures.

1892 Holds his first solo exhibition at his dealer, Durand-Ruel, showing only landscapes, mostly monotypes with pastel; it is the only such show organized by Degas in his lifetime. Otherwise continues to paint, draw, and sculpt his most characteristic subjects, notably the dancer and the female nude.

1895 Degas begins to make his own photographs, forcing friends to pose.

1897 Breaks with his lifelong friend Ludovic Halévy over the Dreyfus Affair.

1900s Despite ill health and failing eyesight, continues to work on drawings, pastels, paintings, and sculpture. For exercise and diversion, walks the streets of Paris.

1912 His *Dancers Practicing at the Bar* (page 174) is sold, fetching a world-record price for the work of a living artist. Moves his studio for the last time; probably gives up working altogether.

1917 September 27—Dies at his home in Paris. Is buried in the Degas family tomb at the Montmartre cemetery.

The first exhaustive study of Degas's art was P. A. Lemoisne, *Degas et son oeuvre*, 1945–49 (reprint ed., 1984, including a supplement by Philippe Brame and Theodore Reff). Lemoisne's work was brought up to date by Jean Sutherland Boggs et al. in *Degas*, the catalogue of the exhibition held in Paris, Ottawa, and New York in 1988. Degas's journals and sketchbooks were catalogued by Reff, *The Notebooks of Edgar Degas*, 2nd rev. ed., 1985 (see also Reff's *Degas, The Artist's Mind*, 1976). The painter's historical role is traced by John Rewald, *The History of Impressionism*, 4th rev. ed., 1973.

Other general works on the artist include Roy McMullen, *Degas: His Life, Times, and Work*, 1984; Denys Sutton, *Edgar Degas: Life and Work*, 1986; Robert Gordon and Andrew Forge, *Degas*, 1988; Henri Loyrette, *Degas*, 1991 (in French); and Richard Kendall, *Degas: Beyond Impressionism*, 1996. A compilation of Degas's writings is in Kendall, *Degas by Himself*, 1987.

Studies of medium and technique include Boggs, *Drawings by Degas*, 1967; Eugenia Parry Janis, *Monotypes by Degas*, 1968; Charles Millard, *The Sculpture of Edgar Degas*, 1976; Sue Welsh Reed, Barbara Stern Shapiro, and Clifford Ackley, *Edgar Degas: The Painter as Printmaker*, 1984; Anne Pingeot, *Degas Sculptures*, 1991; Boggs and

Anne Maheux, *Degas Pastels*, 1992. Studies of the artist's themes include Lillian Browse, *Degas Dancers*, 1949; Boggs, *Degas Portraits*, 1962; George T. M. Shackelford, *Degas: The Dancers*, 1984; Richard Thomson, *Degas: The Nudes*, 1988; Kendall, *Degas Landscapes*, 1993; and Felix Baumann et al., *Degas Portraits*, 1995.

Index of Donors' Credits

Index of Illustrations

Photography Credits

Editors: Mary Christian and Jeffrey Golick
Designer: Kevin Callahan
Production Editor: Meredith Wolf
Picture Editor: Paula Trotto
Production Manager: Becky Boutch

First edition
10 9 8 7 6 5 4 3 2 1

Library of Congress Cataloging-in-Publication Data
Shackelford, George T. M., 1955–
 Edgar Degas / George T. M. Shackelford.
 p. cm.
 "A Tiny Folio."
 Includes index.
 ISBN 0-7892-0201-8
 1. Degas, Edgar, 1834–1917—Criticism and interpretation.
I. Title
ND553.D3S5 1996 96-14101
759.4—dc20

SELECTED TINY FOLIOS™ FROM ABBEVILLE PRESS